SECRET
ARUNDEL

Eddy Greenfield

AMBERLEY

Image Credits

Kathryn S. Kraus/Shortcut Productions: Jailhouse and cells [Chapter 3], Hiorne Tower [Chapters 6 and 9].

Shortcut Productions/Punk Strut Pictures: film still and DVD cover [Chapter 6].

Francis C. Franklin (CC BY-SA 4.0 https://creativecommons.org/licenses/by-sa/4.0): St Walburge's Church [Chapter 9].

Shiftchange (CC0 public domain): Arundel, Queensland [Chapter 9].

OpenStreetMap contributors: Maps [Introduction and Chapter 9]. Data contained is available under the Open Database Licence and the Creative Commons Attribution-ShareAlike 2.0 licence, both available at www.openstreetmap.org/copyright.

First published 2020

Amberley Publishing
The Hill, Stroud
Gloucestershire, GL5 4EP

www.amberley-books.com

Copyright © Eddy Greenfield, 2020

The right of Eddy Greenfield to be identified as the Author of this work has been asserted in accordance with the Copyrights, Designs and Patents Act 1988.

ISBN 978 1 4456 9601 0 (print)
ISBN 978 1 4456 9602 7 (ebook)

British Library Cataloguing in Publication Data.
A catalogue record for this book is available from the British Library.

Typesetting by Aura Technology and Software Services, India. Printed in Great Britain.

Contents

Introduction

When thinking of the word 'secret' the first definitions that come to mind are usually those that imply being hidden or concealed. Of course, if something is truly secret then it would not really be possible to write about. How, then, to write a book titled *Secret Arundel*?

Before even typing the very first word of this book I thought it sensible to look up the definition of 'secret' in a number of dictionaries. Several of them included definitions that are akin to words such as 'little known', 'forgotten' and 'not widely acknowledged'. Therefore, I've used this looser definition to fill the chapters with stories and anecdotes of the more unusual and lesser-known snippets of Arundel's past that I have come across during my research into the town and its surroundings.

With much of Arundel's history being dominated by the castle and the plethora of earls and dukes that have graced its halls, I was keen to avoid this book simply repeating what

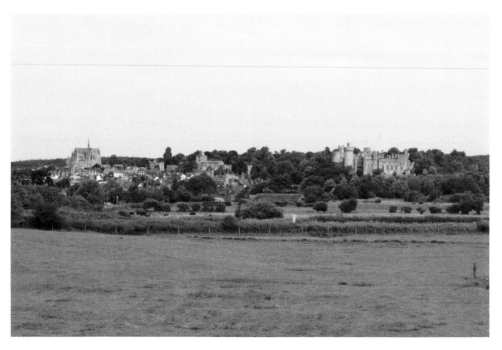

Arundel town.

can already be found in countless other written histories elsewhere. Instead, I wanted to tell the stories of the very townspeople who make Arundel what it is – a vibrant and fascinating place to live, work and visit. Just scratch a little beneath the surface of this popular tourist town and it isn't long before a darker, murkier, mysterious and exciting side is exposed to rival any tales of knights, fine art and royal courts. Arundel certainly has a history that punches far above its size.

This book will cover a wide range of subjects from military and criminal to social and modern history. There will be stories of scandals, weird weather and the downright strange – I hope that you, the reader, will find it all to be of interest. As a final note, there will be a number of references to old currency dotted throughout the book. To the modern reader these can be somewhat meaningless, and so I have put the modern-day equivalent in square brackets immediately after each amount based upon the National Archives currency converter, which is correct up to 2017.

I wish to give special acknowledgements and thanks to the following: Kevin Short, the writer and director of the 2010 award-winning film *Punk Strut: The Movie*, for kindly supplying and granting permission to use stills from the film, jailhouse and Hiorne Tower; Canon Tim Madeley, Dean of Arundel Cathedral, for permission to photograph Bernard Cuthbert Taylor's memorial plaque inside the cathedral and for proofreading the relevant sections of this book relating to the cathedral and the *Titanic* – also thanks to Louise Sharp, the cathedral secretary; Father David Twinley for permission to photograph the churches of St Nicholas and St Mary Magdalene; John Barkshire, the church historian at St Nicholas, for kindly checking through the relevant parts of this book and

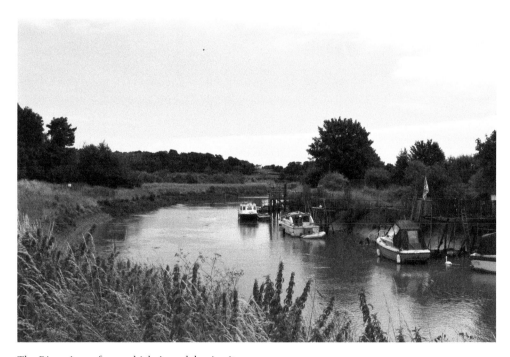

The River Arun, from which Arundel gains its name.

6

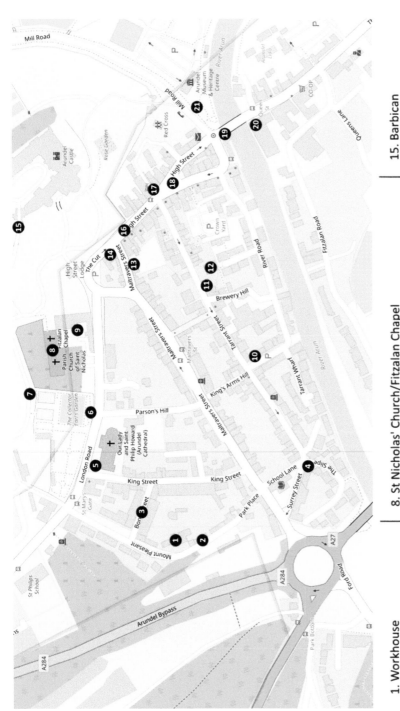

1. Workhouse
2. Providence Chapel
3. 16 Bond Street
4. False Teeth Wall
5. Cathedral Spire
6. Folly
7. Hospital of the Holy Trinity

8. St Nicholas' Church/Fitzalan Chapel
9. St. Nicholas Priory/College of the Holy Trinity
10. Quaker Meeting House/Arun Street Baptist Chapel
11. Congregational Church (Original)
12. Trinity Congregational Church
13. Town Hall
14. Hansom's House

15. Barbican
16. 63 High Street
17. Norfolk Arms Hotel
18. Market Square
19. Arundel Bridge
20. Bridge Hotel
21. Friary Ruins

Key sites. (Openstreetmap)

22. Houghton Forest Bunker
23. RNAS Ford
24. St Mary Magdalene's Church, Tortington
25. Tortington Priory
26. Hospital of St James

27. Mill Street Bridge/Home Farm
28. River Arun
29. Calceto Priory
30. St Barnabas' Church, Warningcamp
31. Poling Preceptory

Surrounding area. (Openstreetmap)

supplying me with additional information; the mayor and members of Arundel Town Council, Sue Simpson (town clerk) and Sue Roderick (events manager) for permission to photograph the town hall and former jailhouse; and finally to the Norfolk Estate for permission to use the photos of Hiorne Tower. I'd also like to give particular thanks to the British Resistance Archive for their immense assistance in helping to locate the almost impossible-to-find Auxiliary Unit Operational Base within Houghton Forest, which would otherwise have remained elusive to me. I heartily encourage visiting their fascinating website www.staybehinds.com for a wealth of information on the wartime Auxiliary Units at Arundel and elsewhere.

I hope that you will enjoy the journey through Arundel's long and fascinating history as you peruse these pages, and hopefully you will discover one or two things that may surprise you about this beautiful town.

DID YOU KNOW?

Although Arundel has been the seat of the Dukes of Norfolk and their ancestors continuously since the eleventh century, they did not take up permanent residency at the castle until 1842.

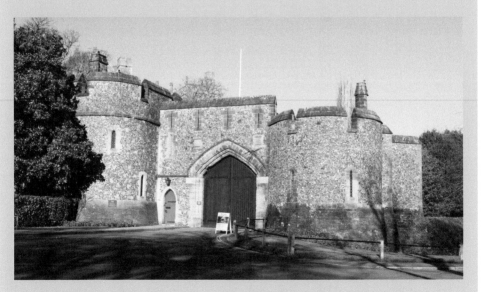

This gatehouse, like the Norfolk residency, is surprisingly modern.

1. Home Guard Spy Scandal

On 14 October 1940, a thirty-seven-year-old man named in the press as William Treutler Holmes and described as a 'German doctor's son' found himself in the dock at Arundel charged with unlawfully photographing aircraft and a wireless station at Royal Naval Air Station Ford on 7 October. Superintendent Frederick Charles Peel opened for the prosecution, stating that this was one of the first cases of its kind in the country.

The story begins on 29 August 1940 when Holmes began work as a civilian labourer at RNAS Ford. On the day in question, Thomas Spencer said that he had spotted Holmes standing up against some wire, on the other side of which was a brand-new Bristol Beaufighter – an aircraft that had only just started to be issued to operational squadrons. Spencer testified that Holmes had the bottom button of his coat fastened, but the two above it open and that there was a bulge inside his coat. Holmes then proceeded to put his hand inside his coat and bend forward. Two civilian riggers approached and leant up against the wire next to Holmes, who quickly lit a cigarette and then wandered off before returning a short while later. Spencer told the two men not to allow Holmes near the aircraft again and ordered Ralph Morley, a rigger, to notify the authorities.

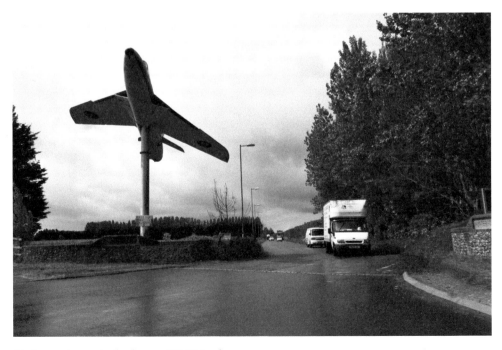

Modern entrance to the former RNAS Ford.

Alan William Over, an Air Ministry warden from Littlehampton, arrived on the scene and stated that Holmes openly admitted to taking photos, eventually producing a small foldable camera from his pocket.

PC Brown testified about negatives found on the film, including one of the Beaufighter and another of a bomb crater in front of the airfield's wireless station – a relic of the devastating air raid that had occurred at Ford on 18 August. The prosecution then called upon George Lancelot Coombes, a photographic chemist of Tarrant Street, to whom Holmes' wife, Cicely, had previously brought another roll of film for development at the beginning of October. The film contained a number of negatives of aircraft.

Harold Sinclair told the bench that he was the commander of Arundel Home Guard and that Holmes was his second-in-command, and that he had employed Holmes to

Victims of the Stuka attack, 18 August 1940, buried at Climping.

work at the aerodrome. He said that Holmes had a long-standing interest in aircraft and used to lecture the NCOs on the subject. Police Sergeant Elphick corroborated these facts, saying how Holmes, following his arrest, made a statement claiming to have taken the images for a lecture he was due to give the Home Guard on aircraft and the effects of bombs. Elphick revealed that Holmes had also voluntarily handed over scrapbooks to Superintendent Peel that were filled with pictures of different types of aircraft that he had been collecting since 1916, to prove that he had a long-standing interest in aviation. However, among the pictures were several aircraft that Mr Coombes identified as having come from the roll of film deposited at his shop by Mrs Holmes – aircraft which an officer from Ford confirmed to have been stationed at the airfield during September.

In summing up for the defence, Mr Falconer stated that Holmes came from a highly respectable family and that he had been educated at Sandhurst, from where he was commissioned as a lieutenant in the Bedfordshire and Hertfordshire Regiment, later transferring to the South African Union Defence Forces and had served several years abroad. In 1934 he resigned his commission owing to ill-health and marital problems and subsequently returned to England to take up residence at No. 24 Maltravers Street with his wife. He then opened a successful riding school in the town. When war broke out in 1939, the business quickly collapsed and finding himself without a job Holmes immediately joined the Royal Observer Corps. Falconer related how, when still at school, Holmes gave a public lecture in Arundel on the subject of model aircraft. He was soon transferred to the Home Guard, where he became Mr Sinclair's deputy and at the time of the trial was awaiting a commission into the Royal Navy.

No. 24 Maltravers Street.

Mr Falconer concluded by complaining of the treatment Holmes had received since his arrest from the people of the town, and that he was constantly being harassed with accusations of being a fifth columnist and a German spy – his father's name being used against him. As such, he had had his pass to RNAS Ford revoked and, therefore, had lost his job. Furthermore, if found convicted the Royal Navy were sure to revoke his commission, which was due any day.

Following discussions, the magistrates returned a unanimous guilty verdict. The chairman declared that it would be a failure of their duty not to convict Holmes and that a sentence appropriate to the crime would be passed down. Holmes was fined a total of £32 15s 10d [£1,290.23] and given three months imprisonment.

This is the story that has been retold over the years, in varying levels of detail, but the truth isn't quite as presented. The 'secret' here is not the story itself – it was quite liberally reported in the national press at the time – but the story that hasn't been told.

Digging beneath the rather sensationalist headlines, the allegations that Holmes was the son of a German doctor does not stand up to scrutiny. In fact, the media's use of the German-sounding name 'Treutler' was also false and was probably done to play on the spy scare aspect.

Born on 21 September 1903 at Hove, Herman William Gottlieb Treutler had actually changed his name by a deed poll on 18 October 1921 to William Holmes. His father, William John Treutler, was not a German. He was born in 1841 in Dinapore, India, as a British subject and came to the UK in 1852, going on to study medicine; he became

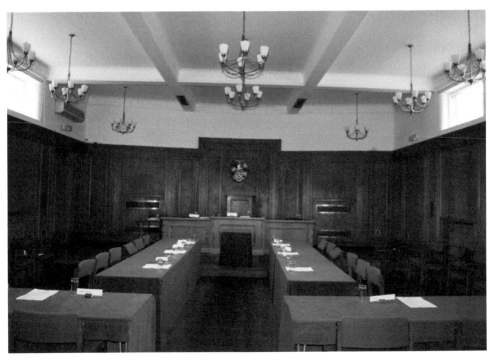

Former courtroom, now the Town Council chamber.

a master surgeon in 1866. During the Franco-Prussian War of 1870, Dr Treutler served with the British Red Cross. Living at Fletching after the war, Dr Treutler then moved to Hove in 1890 until his death in 1915. His first wife, Joanna (née MacLean), died in 1901 and Treutler quickly married Lillian Hewlett Burgess, who had been living with the family. Lillian and Dr Treutler were both accomplished musicians and had performed together in the Brighton and Hove Choral and Orchestral Society. In 1903, Lillian gave birth to William.

After Dr Treutler's death in 1915, Lillian married Arthur Holmes, Arundel's town clerk, in 1917 and it was just four years later that William officially adopted his stepfather's surname. Arthur Holmes' family had held public offices in the town since the 1760s. Among the wedding gifts presented to the couple were a pair of binoculars and a travel clock from the town's magistrates – a gift to which the Duchess of Norfolk had personally contributed.

Holmes family plaque in the town hall.

William went on to marry Arthur's niece, Cicely Holmes, in 1926, and had a daughter (Lilian Patricia Holmes) in 1927. He was now firmly established in the highly respected Holmes family. The nearest connection William had to Germany was via his paternal grandparents. Johann Gottlieb Treutler was born in Silesia in 1813 and married Wilhelmina Louisa Schaller (born in Berlin) in 1838 in Hull. The couple were missionaries on their way to Patna in the East Indies. Evidently, they ended up in India and Johann spent the rest of his working life as a tea planter in Darjeeling before retiring to live at Hove by 1891. Little could be found about William Holmes in the years following his trial and imprisonment. He died in 1970 in the Chichester District and Cicely died in Worthing in 1983. Their daughter, Lilian, passed away unmarried in 1982.

DID YOU KNOW?

Fred Cranham was one of the country's oldest soldiers when he served as a corporal in the Arundel Home Guard at the age of seventy-nine. He first enlisted in the army in 1882 and served in the Nile Expedition of 1884–85. He was prevented from serving in the Second Boer War (1899–1902) due to his age, but was in the National Reserves during the First World War. Of his nine children, five saw active service during 1914–18 and the other four joined the Home Guard in 1940.

2. Houghton's Secret Hideaway

Working Camp No. 46 at Billingshurst was the main prisoner of war facility in West Sussex as the Second World War came to an end. A number of dispersed satellite camps existed at sites elsewhere in the county, the closest to Arundel being around 5 miles away at Westergate, but it was from the main camp in Marringdean Road, Billingshurst, that our story begins.

Although security was naturally tight at the facility, escapes seemed to plague the camp. The first occurred in late April 1946 when two Germans broke free, but were quickly recaptured. Their captivity didn't last long, however, and a week later the pair was on the loose once more. A month later, three more Germans gained temporary freedom, reaching as far as Canterbury before recapture.

Having established a brief background, Arundel's interest in the camp took place on 27 August 1947 when Gottfried Pfeiffer, Helmut Saver and Friedrich Martens, three more Germans, were spotted in Arundel Park. A dawn ambush by police and military authorities failed to capture the men when the headlights of a car bringing in reinforcements drew

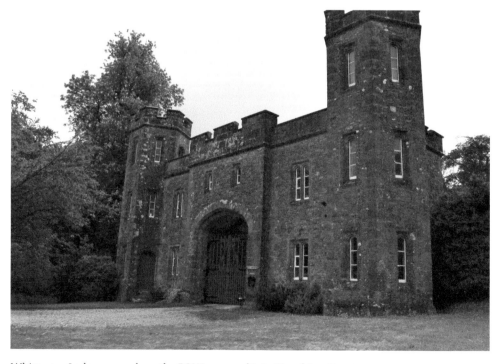

Whiteways Lodge, near where the POWs escaped into Houghton Forest.

attention to a group of police officers who had been silently approaching the fugitives, dazzling them and allowing the men to make their escape to Houghton Forest. The men had broken out of the prison camp on 21 August and had a lot to lose if they were recaptured. They had all been involved in a previous escape attempt, for which they were due to face a court martial for burglaries committed during their time on the run.

Ironically, the prisoners had located a formerly top-secret bunker in Houghton Forest which had been constructed in advance of an expected Nazi invasion in 1940. The bunker was to be the base for an Auxiliary Unit patrol, which would have had the duty of remaining behind enemy lines to sabotage supply lines and cause as much disruption as possible before they were inevitably captured or, more likely, killed. In 1947, however, it was not the British making use of the bunker to evade the Germans, but the Germans using it to evade the British! It was believed that the men were using the bunker (so much a secret that neither the police nor the military really knew of its location) during the day to hide, coming out at night to steal or forage for food. It was likely one of these nocturnal scouting trips that nearly led to their capture in Arundel Park.

A team of police, local woodsmen, armed soldiers and an RAF helicopter mounted an unsuccessful search of the forest. An over-eager farmer at Binsted caused some embarrassment when he and his farmhands captured one of the 'Germans', but it was later revealed to have been a deaf Pole who they had chased before overpowering him and tying his arms and legs – a mistake not realised until the police arrived on the scene. In the meantime, the Down Chalet, an unoccupied house in Houghton, had been found to have been broken into. Furthermore, food had been reported as having been stolen from a

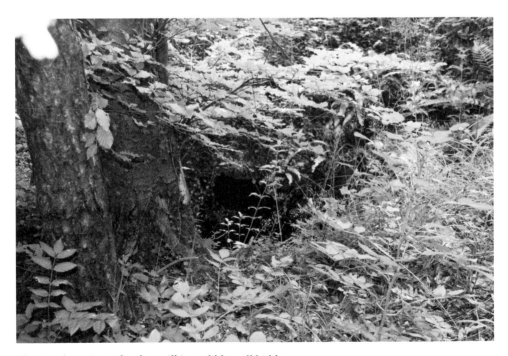

The Houghton Forest bunker, still incredibly well hidden.

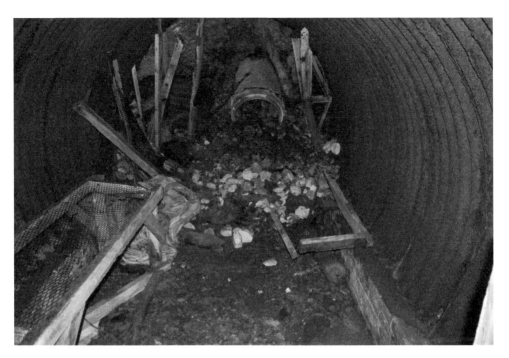

The original beds used by the prisoners still survive inside.

nearby farm and a motorbike from a house in Slindon had also gone missing. Mr Ingham, the owner of Walberton Farm, had spotted two men on his land on the afternoon of the 27th taking water from a standpipe before running away once spotted. Food had also gone missing from the larder of the farmhouse.

The men were finally captured the following day by pure accident. A police officer on patrol along Worthing's promenade spotted a speeding car spinning off the road and onto the beach near Beach House. As he ran over to investigate, three men casually got out and walked towards him, offering no resistance as they were revealed to be Pfeiffer, Saver and Martens. They had a quantity of stolen food and cigarettes on them and had partially exchanged some of their prison clothes for civilian dress. The officer placed the men under arrest and took them to a nearby hotel to await collection. The car, however, remained stuck on the beach just above the high-water mark for several days as enquiries were made into its ownership. The bunker in Houghton Forest still survives largely intact today, including the bunk beds, albeit extremely difficult to find.

3. Law and Disorder

Completed in 1836–38, Arundel's town hall had cells built within its basement for the holding of convicted criminals sent down from the courtroom above. Now a popular night-time entertainment venue, the jailhouse had a long history of incarcerating convicted felons for a wide range of crimes and misdemeanours as they awaited transport to the county gaol. The jailhouse had replaced a former lock-up that existed from around 1754.

This unassuming passageway off High Street leads to the jailhouse.

DID YOU KNOW?

The town hall and jailhouse was built at the personal expense of the 12th Duke of Norfolk on condition that he received the northern part of the High Street, which he wanted to enclose within the walls of the castle estate. This has resulted in today's High Street losing around two-thirds of its original length.

The High Street originally continued beyond the castle walls.

Early Crimes (Pre–1836)

Rhoda Parrott was examined on a charge of child stealing on 28 July 1817. The six-month-old in question was the infant son of William Hamson and his wife, Matilda. Mrs Parrott had become personally acquainted with the Hamsons the previous year and on 19 April 1816 she had managed to persuade Mrs Hamson, albeit reluctantly, to allow her to take the child out for a walk. Nothing was seen or heard of Rhoda or the child until 23 July 1817 when she was spotted at Hounslow Barracks, having since married a soldier. At the examination, Rhoda stated that she had fallen in love with Mr Parrott and in an attempt to persuade him to marry her she had stolen the child, planning to present him as their illegitimate son. However, the baby sadly died in the winter of 1816–17 and was buried in the grounds of St Nicholas Church – facts that were only revealed to Mrs Hamson at the examination.

A crew of a ship were convicted of smuggling at Arundel in late April 1823, when between fifty and sixty tubs of foreign spirits had been seized at sea by the excise men

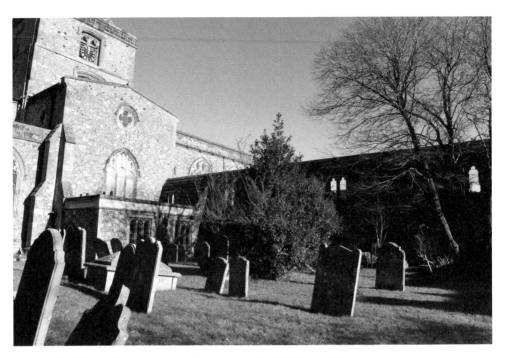

Six-month-old baby Hamson is buried somewhere in St Nicholas' Churchyard.

and taken for safe keeping at a government warehouse in the town. A few days later and another two men were committed to Horsham Gaol for smuggling, one of whom was a foreman at the Mill House Brick Kilns at Arundel.

On 22 September 1828, Henry Bennett and Richard Northeast were each sentenced to one month imprisonment with hard labour for stealing grapes from the garden of Thomas Walder at Arundel. This seems like a very harsh sentence from the modern perspective, but considering the men were threatened with transportation to Australia they appear to have got off considerably lightly!

A Mr Robinson was one of the last people tried at Arundel before the town hall was completed when, on 25 June 1835, he was sent to prison for smuggling. When the revenue cutter was spotted, Mr Robinson was seen to hurriedly offload his cargo overboard. The attempt to cover his crimes didn't work and the Arundel magistrates had no trouble in convicting, even though the evidence was still out at sea at the time of his trial.

DID YOU KNOW?

The Arundel Society for the Prosecution of Thieves and Felons became the UK's only private police force in 1938. It was formed in the 1780s, but hadn't caught any criminals since 1912.

The First Prisoners (1836–76)

On 11 December 1837, George Hill found himself in the dock of the new courtrooms in the town hall for poaching on the Norfolk Estate. He was sentenced to two months imprisonment with hard labour.

A boy was in court on 6 March 1841 on a charge by the future 14th Duke of Norfolk for obtaining money from him under false pretences. The boy called on the duke with a letter requesting money for a widow living in the town. The duke sent the boy away, asking that he return a while later. In the meantime, he proceeded to make inquiries and found that the whole thing was a lie. The MP for Huddersfield told the court he had received a similar letter. The boy had also attempted the same with the future prime minister, Lord John Russell. The boy was sentenced to two months imprisonment.

In another particularly interesting case, the gatekeeper at the Ford railway crossing was sent to prison for one month for neglect of his duties when, in early May 1847, he had left the gate in the care of his wife so that he could attend to his garden. The gates had been left open and, as a threshing machine was being driven through, a train crashed into it, completely destroying it and so injuring the horse that it had to be euthanised.

Another smuggling case was heard in Arundel on 6 October 1857 against Messers Bruce and Everett of Portsmouth, Wicks of Angmering, and Elliott, the master of the *Intrepid*, for smuggling a large consignment of spirits. The court sentenced the crew to eight months imprisonment, with Elliott receiving nine months.

A rather strange 'crime' was in court in 1858 when Mark Redman and Charles Terry appeared on a charge of wilful and malicious damage in Tortington in that they had mown

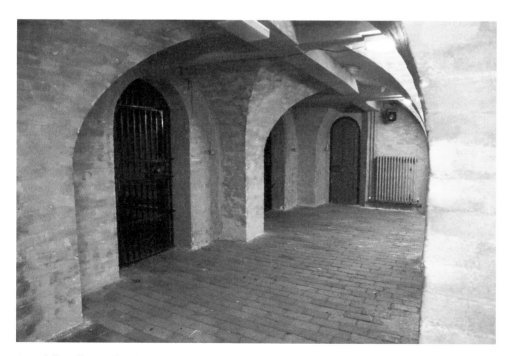

Arundel's jailhouse. (Kathryn S. Kraus/Shortcut Productions)

some grass along the riverbank! They were each fined 12s 3d [£36.22], or to fourteen days hard labour in default of payment.

Another unusual story surrounds the presence of a woman in the cells in late February 1866. The superintendent of Chichester City Police, Supt Everett, had a bell installed at the head of his bed in order that he could be summoned in the event of an emergency. On this particular morning he was awakened by the bell and rushed to see what the emergency was. He was met with a constable and a woman who appeared as though she was ready to give birth imminently. They carefully escorted the woman to the city's workhouse, where a team of nurses and a bed were prepared. As the nurses began to remove the woman's outer clothing they found concealed around her midriff was a sack, two guano bags, a great coat, a bag of nails, a padlock and a number of other items. As each item was removed the 'pregnant' woman was revealed to be anything but and the nurses placed her back in the care of the police. It turned out that she had spent the previous night at Arundel where she had stolen the various objects. She soon found herself being escorted back to Arundel for a stay in the cells.

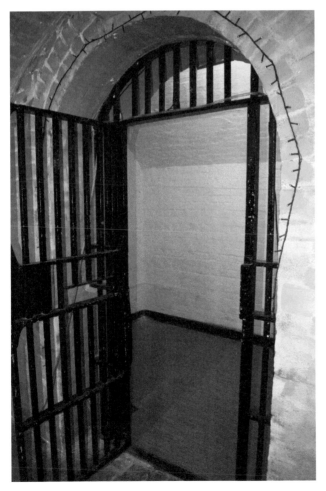

A cell beneath the town hall.

The attempt to defraud the 14th Duke of Norfolk in 1841 was unsuccessful, but the same cannot be said when his son, the 15th Duke, became the target of a cheeky conman in November 1874. On this particular occasion, a man wrote a letter pleading for financial assistance after he had fallen upon hard times and that he intended to enlist in the army. The duke looked favourably upon the man's plight and duly sent him a sum of £5 [£313]. A few days passed and the duke's estate agent reported that he had been forced to prosecute a poacher who had repeatedly been shooting pheasants in Arundel Park. It turned out to be the same man as wrote the letter and that while he was being convicted, the duke was unknowingly sending the money to pay his fine!

Murder (1877–79)

A couple of murders occurred in Arundel between 1877 and 1879. The first involved the body of a child sent from Victoria to Mr W. W. Mitchell in Arundel in February 1877. When found on the train at the station, the body was sent to the coroner, where a verdict of wilful murder against persons unknown was returned. A few days later the secretary of state issued a reward of £50 [£3,309.24] for information leading to the conviction of the murderer, a crime that remains unsolved.

The second took place on 15 February 1879 when the body of sixteen-year-old Frederick Bowley, a parcel collector for the Norfolk Arms Hotel, was found, having been violently murdered in a lane near to the Duke of Norfolk's boathouse (now the gardens behind the friary ruins). His head had received extensive injuries and a large quantity of blood

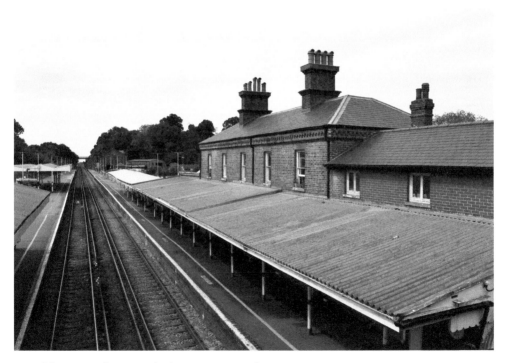

Arundel station, where a grisly discovery was made in 1877.

Above: The friary gardens, scene of murder in 1879.

Left: Site of the Duke of Norfolk's boathouse behind Arundel Museum.

stained the area around the body and a bloody handprint was plastered on the boathouse wall. The boy's watch and some coins were scattered about the ground and it seems the only thing taken was a single sovereign. Two people had been spotted earlier that night in the lane.

On 18 February, James Hennessey, James Turner and Mary Turner were charged at the town hall with his murder. The prosecution argued that Mary had lured Bowley into the lane after he had made his last stop for the night at the Bridge Hotel, at which point the two men mugged and killed him in the struggle. She had been seen with the boy before the murder took place and suspicious stains on Hennessey's clothes were presented as evidence. James Turner, on the other hand, was cleared of involvement. The remaining two were remanded and held in the cells.

The pair was in front of the magistrates again on 24 February. Three witnesses gave evidence and alleged that they had seen the prisoners in a lodging house on the night of the murder and that Hennessey had gone out for several hours late in the evening. One of the witnesses, Phoebe Harris, alleged overhearing Hennessey saying that he intended to get hold of some money and food, even if it landed him in prison. No further evidence

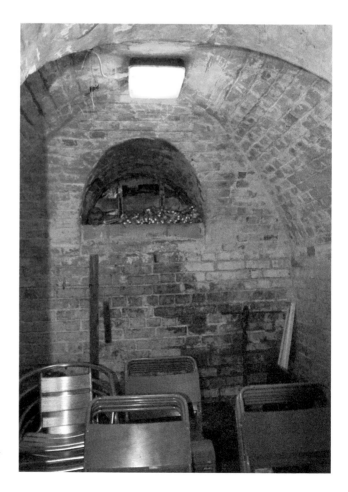

The solitary confinement cell for condemned prisoners, now a storeroom.

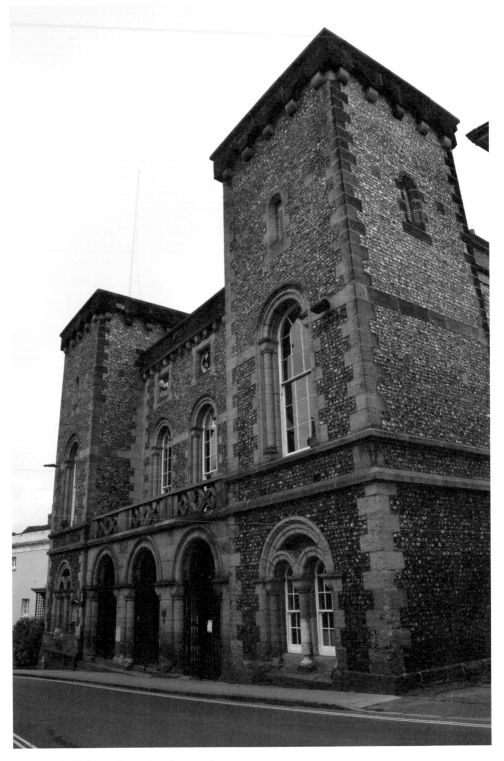

The town hall, formerly used as the town's courtrooms.

was given against Mary and another of the witnesses, George Smith, swore that she was not the same woman as was seen with Hennessey on the night of the murder. Hennessey's clothing had been sent to Guy's Hospital for forensic examination of the stains and the pair were further remanded in custody.

The third hearing took place at the town hall on 7 March, at which the mayor discharged Mary Turner on account of her alibi being proven, but Hennessey was committed for trial and continued to be held in custody. However, on 23 April, the Lewes Grand Jury dismissed the charges against him. As with the case in 1877, no person was ever convicted for the murder of Frederick Bowley. A third unsolved murder occurred in Arundel almost seventy years later, when the body of Joan Woodhouse was found strangled near a lake in Arundel Park on 10 August 1948. A man was arrested and charged with the crime, but was found not guilty, leading to the first, and so far only, attempt to privately prosecute for a murder. This, too, was unsuccessful and the crime remains unsolved and mired in rumour and theories of cover-ups to this day. A fourth similarly mysterious murder then occurred in August 1980, when the beaten body of a Brighton antiques dealer was found washed up in the Arun near Arundel. Although a local man was originally arrested for the murder and eventually convicted of manslaughter, the events and evidence were mired in suggestions of cover-ups by the security and intelligence services, and the conviction was quashed in 1996, leaving the murder still unsolved to this day.

Strange Cases and Shocking Crimes (1880–99)

A curious incident occurred at the town hall in June 1886, when an inquest was held on the body of Edmund Marshall. He had been held at Littlehampton for drunkenness, but as he reached the dock on the date of his hearing, he suddenly fell back dead. The cause was found to have been heart disease.

Mob rule reigned in Arundel on the night of 18 August 1890. It began when Mr Trim, a butcher in Tarrant Street, had handed management over to Mr Fennell. The agreement between the men stated that Fennell was to run the shop for at least twelve months before Mr Trim could seek to dispose of the business. On this basis, Mr Fennell gave up his home and job in Brighton and moved into the Tarrant Street premises. Around ten weeks passed before Mr Trim stated he had sold the business to another Brighton man and Fennell had to vacate. The latter refused to go and legal proceedings were started to gain an eviction. Fennell still refused to go.

On the 18th, Mr Trim and his son began to forcibly remove Fennell's furniture at 8 p.m. and a crowd began to assemble. Finally, Fennell was manhandled out of the building. The crowd, increasing in size, grew hostile towards Trim. Mrs Fennell and the children were taken to the Swan Inn for shelter – and just in time! Mr Wakeham entered the butcher's shop to try and act as mediator between the parties, but the crowd believed he was there to assist in the eviction and violently assaulted him. Sustaining numerous blows to the head, he had to be taken to the town hall for his own safety. Stones then began to be hurled at the butcher's shop, smashing every window in the building. The rioting continued endlessly until midnight. The following night another large and angry mob assembled outside Trim's house. More stones were hurled through the windows, as were firecrackers. Again, the crowd had full control of the street all night, before slowly dissipating towards midnight.

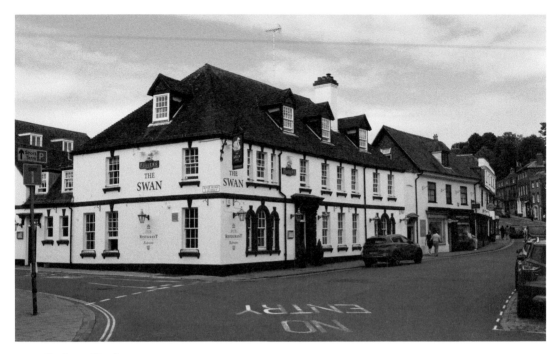

The Swan Hotel.

On 29 August 1890, Mr Loder Cooper stood before the magistrates to demand summonses against seven men identified as the ringleaders of the riots. Surprisingly, the mayor of Arundel, as chief magistrate, suggested that matters be dropped since no further disturbances had taken place! The argument didn't hold sway and the seven men appeared before the bench on the 11th. The men pleaded guilty and were bound over to appear at the Quarter Sessions.

George Holland was sent to Broadmoor Criminal Asylum in October 1894 for cutting a lamb's throat. The prisoner stated that he didn't know what came over him and had a sudden need to see blood. Arundel surgeon Mr Evershed informed the court that it was his medical opinion that Holland had become 'afflicted with blood mania'. He then warned that Holland posed a risk, because if he could not find an animal when struck by one of his urges to see blood flow then it was probable that he'd attack another person. The prosecution had also linked Holland to eight other sheep killings around the area.

Towards the end of the nineteenth century, Arundel made a number of headlines for some rather strange rulings. One such case in 1894 declared a rat to be a domestic animal, cruelty to which would result in a fine or imprisonment. A London butcher was fined £34 5s 6d [£2,679.35] in June 1896 for supplying diseased meat to a local army camp. In 1897, Mrs Lamport of Littlehampton was being sued two guineas by a book supplier. She had ordered some books in her own name, but payment was to have been made by her husband, who had since died. The judge ruled that it was her deceased husband who was liable to settle the bill, but because the order was in Mrs Lamport's name then Mr Lamport's estate could not be sued.

Tarrant Street, scene of riots for two nights in 1890.

Turn of the Century (1900–19)

An Arundel postman was in the dock on 4 July 1902 for stealing letters. George Francis Standing worked the night shift at Arundel station and was responsible for collecting the postbags. In the early hours of 15 January, a consignment of post from the station arrived at the main Arundel post office with a number of letters opened and another missing completely. Standing's sister-in-law attested to the court that she witnessed him getting his wife to sign a postal order and cash it in. The jury found the man guilty of theft, after which Detective Lainchbury informed the court that during the three years Standing had held the job, a large quantity of post had been reported missing and that he was, at the time of the trial, already serving a three-month sentence for theft. He was handed down twelve months hard labour.

On 26 May 1907, a 'fantastically dressed' man caused alarm among the cathedral's congregation when he took up a pew immediately behind the Duchess of Norfolk. During the service he continued to act very eccentrically, pulling strange faces at the worshipers. After the service, he went on to Littlehampton where he attracted the attention of the police. He was arrested following a violent struggle and upon searching him they found a revolver. The man was identified as Captain Wyndham Paulet St John-Mildmay, a former justice of the peace and son of Revd Charles Arundell St John-Mildmay. He was certified as insane and committed to Graylingwell Asylum.

Another strange case was that of Frank White, who, on 5 January 1909, was sentenced to three months imprisonment for obtaining 1s [£3.91] under false pretences. He had sold a pound of margarine as fresh country butter.

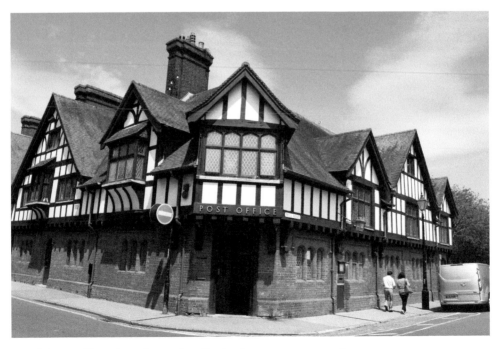

Arundel post office, where George Standing's crimes were uncovered.

Great consternation was caused in the cathedral in 1907.

Boom and Bust (1920–38)

Great consternation gripped much of the region on 22 March 1924 when twelve-year-old Iris Paice went missing from Arundel. The recent violent assault and murder of eleven-year-old Vera Hoad at Chichester less than a month earlier still haunted the public conscience – a crime which still remains unsolved. Iris had apparently gone out in the morning to pick primroses with a friend, but had failed to return by early evening. The friend in question had also failed to see Iris at all that day. Search parties from as far away as Chichester descended on Arundel to assist with the searches of the Downs and surrounding countryside and the local Boy Scouts were called up to help search local woodlands. A huge cheer was finally heard ringing around the town at 21.45 when news that Iris had been found safe and well in Brighton was received. It turned out that Iris, who had recently moved to Tarrant Street, disliked the town and had set out for Brighton.

The mass poisoning of 155 pheasants with arsenic saw David James Gregory jailed for three months with hard labour in December 1930. A co-worker had told Gregory that the head gamekeeper was seeking to have him discharged and that he should kill the birds to inflict revenge. As it turned out the rumour was unfounded and the co-worker was simply out for his own perverse gratification at Gregory's expense.

A sign that the Great Depression was hitting the poorest is probably evident at a sitting of the magistrates in May 1933, when there were six cases under consideration, all for begging or for absconding from East Preston Workhouse. Three were given seven days hard labour and the others received ten days hard labour.

Above: Arundel's former police station in Maltravers Street.

Left: The town hall entrance housed the town's stocks.

Wartime Crime (1939–45)

Contrary to the legend of the Blitz Spirit, crime thrived during the war years, and Arundel was not immune. Most cases brought before the magistrates were fairly mundane, but on 18 September 1944 the body of Amelia Elizabeth Ann Knowles was found at her cottage at No. 20 Tarrant Street. The court heard that the accused, Andrew Brown, an aircraftman in the RAF, had visited several inns before passing Miss Knowles' house. He knocked on the door and, as she opened it, he forced his way in and beat her until she was dead. He then took some money from the house and left.

Brown's defence said that he was insane at the time of the crime. Dr A. Baldy told the court that he had examined the prisoner at Lewes Prison and declared that he was definitely not insane. However, there was evidence of an epileptic-type illness and in his professional opinion he believed that Brown suffered from 'absence seizures', probably intensified by his drinking. Two other medical doctors concurred with these conclusions. However, a third doctor disagreed and said that there were no signs that Brown suffered from epilepsy. Brown pleaded not guilty to murder, but guilty to manslaughter at his trial on 7 December. The jury disagreed and quickly returned a verdict of murder and the death sentence was passed by the judge. He was hanged at Wandsworth on 30 January 1945, being the only person ever convicted for murder in Arundel.

Hanging was a warning given to twelve Royal Australian Air Force servicemen on 13 November 1944 for killing and butchering a lamb at Arundel following a night of heavy drinking. The chairman of the bench told the men that in the not too distant past

No. 20 Tarrant Street, where Miss Knowles was violently murdered.

this crime would have seen them all hanged, but they were fined a total of £60 [£2,133] – triple the value of the lamb.

A couple of months earlier, Sir Herbert Williams, the Conservative MP for Croydon South, was in the dock at Arundel for entering a prohibited area at East Preston and was issued with £10 10s in fines and costs [£373.29].

DID YOU KNOW?

The last executions in Arundel were during the Civil War. On 22 December 1643 Parliamentarian solider Richard Smith was hanged on Arundel Bridge for being a Royalist spy. A few days earlier another man was hanged for attempting to assassinate Parliamentarian commander Sir William Waller in the town.

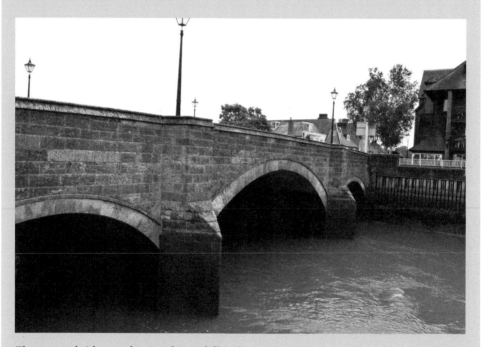

The present bridge, on the site of Arundel's only executions.

4. The Workhouse

Arundel has had three workhouses since the first was built in 1682 and they remained in continual use until 1873. Each one was built on the same site, and so the only visible remains today are that of the last workhouse built in 1831. The first building was small, but lasted for almost a century before a new one was constructed in the garden. Up to this point, Arundel's workhouses had been operating firstly under a law dating back to 1601 which essentially established the workhouse as a place where the so-called 'idle poor' (a phrase which loosely equated to any able-bodied adult out of work) would be forced to undertake unpaid work in order to receive poor relief. This law also placed responsibility for caring for the poor and the elderly into the hands of local communities for the first time. Although still an inhumane institution from the modern perspective, it was nonetheless an improvement upon the previous state of affairs whereby the 'idle poor' were compulsorily flogged in public. The 1601 Poor

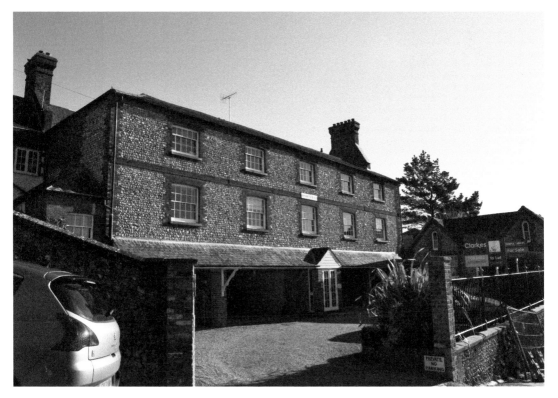

The former workhouse.

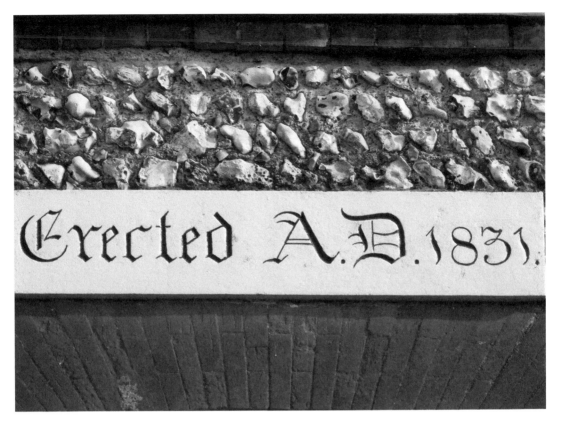

The workhouse plaque, commemorating its opening in 1831.

Law Act also placed responsibility for setting the rate of taxation into the hands of the communities, leading to a situation where some communities were more generous in their care than others, resulting in people moving around in order to take advantage of these inequalities. Naturally, as the number of people in one place requiring relief increased, the rate of taxation also had to rise. This was unpalatable to the ratepayers in these towns. In 1662 the settlement laws were passed to prevent people from being able to claim poor relief in a place that they were perceived to have no lawful right to be, and allowed the guardians to forcibly remove entire families to another town or village. This Act remained in force until 1834.

This system was still unworkable, expensive and led to increasing demand among the public for a more humane treatment of those less fortunate. As a result, Gilbert's Act of 1782 was passed two years after Arundel's second workhouse had been built. As such, Arundel became a Gilbert Union for the remainder of its existence, even after legislative reforms in 1834 when most other workhouses in the county went over to a new system of operating. The 1782 Act provided that workhouses should only be for those who were elderly, ill or infirm, with the able-bodied having to receive relief or employment outside of the workhouse. For the first time it also stopped inmates from

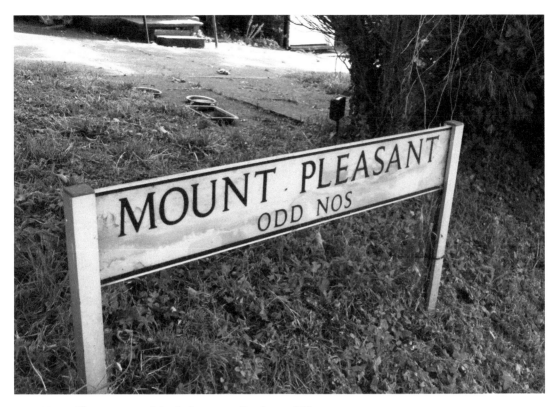

Mount Pleasant was originally known as Poorhouse Hill.

being forced to observe Anglican religious services if they followed a different faith or denomination.

Arundel resisted reforming in line with the Poor Law Amendment Act of 1834, probably to the gratitude of the workhouse inhabitants, since the 1834 Act was very much a regression. It mandated that the deterrent principle of the pre-1782 era (i.e. that workhouse conditions were deliberately poor to discourage all but the most desperate from entering) was enhanced and it forced the segregation of inmates (males from females, adults from children) and the confinement of paupers. As seen in the previous chapter, absconding from an 1834 Act workhouse would result in prison.

Arundel's third and final workhouse was built in 1831 in Poorhouse Hill, later changed to the more aesthetically pleasing Mount Pleasant in the 1920s or 1930s, on the site of the previous two institutions. It remained in operation in this capacity until 1869 when all of the few remaining Gilbert Union workhouses were abolished. In this same year, the East Preston Poor Law Union brought Arundel within its oversight and the town's workhouse was finally closed when a new institution was built in East Preston in 1873. The building was handed back to the Duke of Norfolk's estate that same year, being put to a range of uses over the following century, eventually being converted into private flats in 1985.

DID YOU KNOW?

In 1871, shortly before the workhouse closed, there was a woman aged 102 years living as an inmate.

In terms of residents, there were forty-one people living at the workhouse in 1841, of which twelve appear to have been staff. A decade later the number had dropped to thirty-five; the youngest inmate was eleven-month-old Frances Hoare and the oldest was Susanna Blackman, aged eighty-three. The population more than halved by the next and final census taken during the workhouse's existence, in 1861: just sixteen, of which two were staff. This latter census return is unusual in that it included a number of interesting side notes about the inmates. For example, we learn that Ellen Finch was 'brought up in workhouse' and that Ellen Varion was an 'unfortunate pauper' (probably meaning that she had a learning disability). Ann Barnett was 'deserted by husband' and Frances Hoare, who we first met in the 1851 census, had been deserted and originally housed in St Marylebone Workhouse before being removed to Arundel, along with her brother, George Hoare. The two oldest inmates were ex-servicemen: seventy-six-year-old William Jackson had been a soldier and John Bell, ten years his senior, was a retired sailor.

The only indication today that a workhouse existed in Arundel.

DID YOU KNOW?

Arundel once had a pest house just east of London Road. Pest houses were used to forcibly quarantine people with infectious diseases until they recovered, or more likely died and their bodies disposed of.

Site of the pest house north-east of London Road.

5. Lost and Disused Churches

The title of this chapter refers to churches, though we will actually be taking a look at other places of worship, including chapels, priories, friaries and a Knights Hospitaller preceptory.

Arundel Priory (1102–77)

The history of the first priory at Arundel is poorly documented and little known about. The original site of the priory is not known, but it was founded by Roger de Montgomery shortly after the Norman Conquest with land donated for the erection of an alien house of Benedictine monks as a cell of the Abbey of Séez. The priory was completed in 1102 when the first prior, a monk from Séez, took up office in Arundel. The priory existed on this site for a little over seven decades, when it was transferred to a new site close to the present Church of St Nicholas in 1177.

St Mary Magdalene's Church, Tortington (*c.* 1140–1978)

It is quite possible that Tortington has the smallest complete church in Sussex (Lullington's famous one being only the remains of a much larger church). The first mention of it was

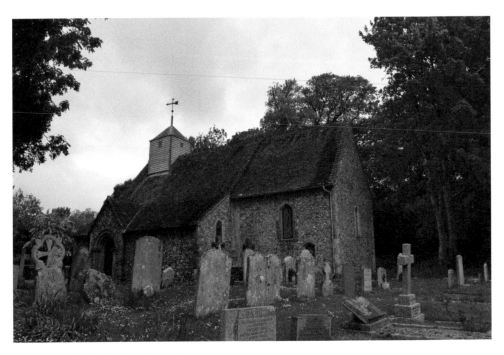

St Mary Magdalene's Church, Tortington.

of a rectory in around 1150, but archaeological dating of the doorway and chancel arch push back this date by around another decade. Unusually, restoration of the church in 1868 was minimal, being largely confined to rebuilding the thirteenth-century south aisle and returning the porch back to its original position. As a result, the church seen today has a fairly close resemblance to the original built in the mid-twelfth century.

A chapel once existed south of the chancel; a small fragment of it can still be found in the exterior wall. Similarly, the church once had a steeple, but this was replaced with a small bell turret in the eighteenth century. A vestry was added to the north side in 1892 and the church was restored again in 1904. Electric heating was installed in 1935 at a cost of £55 [£2,786.44], but with attendance declining the church was declared redundant in 1978 when it was passed into the care of the Churches Conservation Trust, though it still remains consecrated, holds four services annually and is still used for weddings and funerals, with the churchyard remaining open for burials.

Evidence of a former chapel south of the chancel.

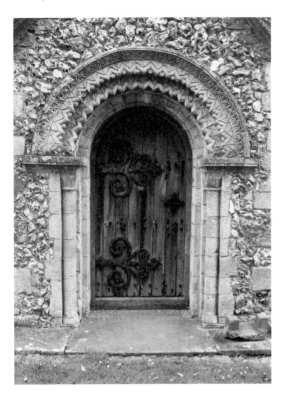

Tortington's Norman doorway.

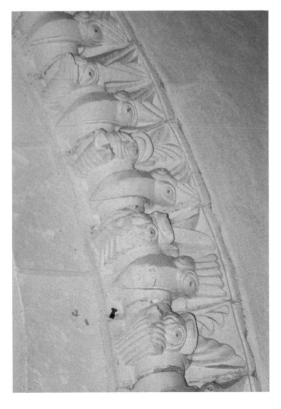

The chancel arch beakheads.

Among the particularly interesting features of the church are the Norman doorway and chancel arch. The former has a richly decorated chevron pattern, and the latter is of particular importance for the highly unusual beakhead carvings. The beakheads are extremely uncommon in Sussex, with the only other known examples being at Shoreham, Broadwater and Buncton. A late medieval pew still survives inside, as does the twelfth-century font and the seventeenth-century oak pulpit.

DID YOU KNOW?

In the thirteenth century, an early Jewish community existed along Mill Lane, which was formerly known as Jury Lane (as a corruption of Jewry Lane). This community appears to have gone by the mid-fourteenth century. Another small Jewish community appears to have established itself at Arundel by the end of the eighteenth century.

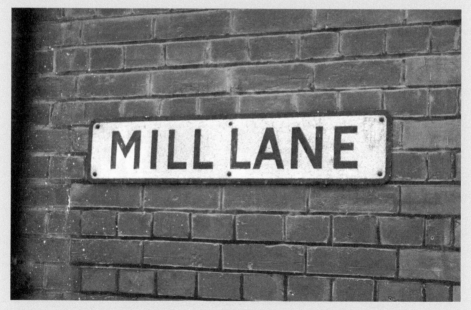

Mill Lane, once home to a medieval Jewish community.

Calceto Priory (c. 1150–1525)

Originally called Pynham Priory when founded by Adelize (wife of William d'Albini and former queen consort to Henry I) in around 1150, this religious house on the causeway quickly gained the nickname of Priory de Calceto in reference to its location.

Unlike the Benedictines at Arundel (later St Nicholas) Priory, Calceto Priory housed a community of three Augustinian canons. Queen Adelize had also built the first bridge

at Arundel and the causeway which passed by the priory. It was the tolls collected from both of these that funded the monks, and the castle estate donated a bundle of wood each year. In return, the monks were to maintain good repair of the priory, the bridge and the causeway and to worship daily in the chapel of St Bartholomew within the priory. Small grants were given to the priory over the decades, but it was never anything more than a very small, impoverished community – so much so that unlike the other monastic houses, Calceto Priory was not self-sufficient. In fact, so poor were the Augustinians here that in 1345 the priory was completely exempted from all taxation.

In 1355, the prior, Robert Coitere, was suddenly deposed from office. He was sent to the priory at Shulbrede near Lynchmere to do penance for his mysterious crime. Although the prior of Shulbrede reported favourably upon Coitere, the Earl of Arundel wrote to the Archbishop of Canterbury complaining that he had been bringing scandal upon the Order. As a result, the archbishop ordered that Robert Coitere underwent more severe penances and be completely separated from the outside world. To ensure this, the archbishop threatened the prior of Shulbrede with excommunication if Coitere failed to abide by the ruling.

From 1380 until at least 1441, there were only ever two canons residing at Calceto. Debt further crippled the priory and by 1478 the building was in a poor state of repair, and the books and other equipment inside had been reduced to just the bare essentials. Improvement was made by the next visitation in 1521 under the management of Prior William Aylyng, but upon his death in 1524 just a single canon remained and the building quickly fell into disrepair. By this time, Cardinal Wolsey had already gained permission to

The priory's tower is just visible through the trees.

suppress the priory and it was subsequently dissolved in 1525. The ruins were eventually incorporated into Calcetto Farmhouse, though only the tower of the priory exists today.

Priory of St Nicholas (1177–1380)

A pre-Conquest establishment of twelve secular canons already existed on this site, though nothing is known of it until after this date, when the four or five Benedictine monks from the priory transferred here in that year (the Earl of Arundel having ordered the secular canons to vacate the buildings). The priory thrived here for a considerable amount of time, quickly gaining the advowsons of a number of churches as far away as Cocking, Billingshurst and Kirdford by 1200. In stark contrast to the extreme poverty of Calceto, the priory had a reasonably large annual income by the end of the century, despite only having no more than around six inmates. In 1340, a small plot of land at St Mary's Gate was given to the priory on which was erected a Chapel of St Mary. In 1340 the plot of land, originally only large enough for the building, was extended to some 30 acres.

Due to being an alien house, King Edward I temporarily seized the priory during his wars with France, as did Edward III in 1337. By this time, control of the priory remained in the hands of the monarchy rather than with the Abbey of Séez. In 1376, the 3rd Earl of Arundel left money in his will to found a chantry within the castle. However, this wish was not carried out, since the 4th Earl did not consider that the castle was a suitable location for such an establishment. Since all the monks, with the exception of the prior, had abandoned the Priory of St Nicholas owing to the ongoing wars with France,

This wall marks the western range of the former priory.

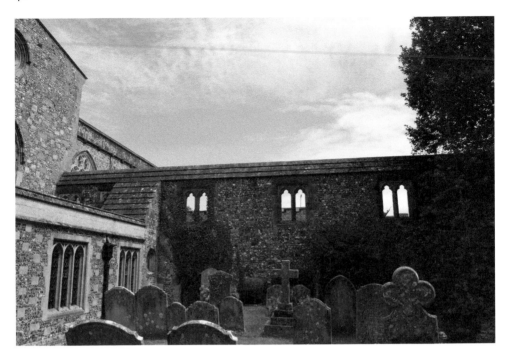

The wall gives a hint as to the priory's appearance.

the 4th Earl decided that this would make a more suitable site to found the chantry. Permission for this was obtained from Richard II, the pope and the abbot at Séez and the priory was dissolved in 1380, with the College of the Holy Trinity established on the site.

By the end of its existence, the priory was square in shape around a central courtyard, with much of the ground plan still being traceable today. The north range included what is now the Fitzalan Chapel and the wall dividing the churchyard of St Nicholas Church with the grounds of St Wilfred Priory formed the western range, although the present wall is not original to the priory. In the north-east corner was the master's house with steps into the chapel. The buildings of the present St Wilfred Priory incorporate the remains of the former south and east ranges.

Tortington Priory (*c.* 1180–1536)

The Augustinian Priory of St Mary Magdalene at Tortington was founded, it is believed, by Alicia de Corbet in around 1180. She was a member of the d'Albini family, perhaps being a sister of William d'Albini.

The earlier history of the priory is very sparse, but in the early to mid-fourteenth century a number of scandals brought the place into disrepute. The first occurred in 1331 when Sir Henry Tregoze accused Prior Walter and two canons from Tortington of having broken into his park at Wiggonholt near Storrington. In 1376, Prior John Palmere was on the receiving end of a papal bull accusing him of allowing the priory to fall into disrepair, of squandering the resources of the priory and overindulging in life outside of the monastery – charges for which he was brought to trial. It should be mentioned that just

Site of Tortington Priory.

like Shulbrede Priory, Tortington was seemingly used as a reformatory for insubordinate monks. In 1402, one of the canons decided to withdraw from the priory and had allegedly taken a quantity of jewellery and other important documents with him. The visitation of 1478 also revealed a laxity in the enforcement of rules. Little improvement ever seems to have occurred, since the final visitation in 1527 reported both the building and the running of the priory to be in a very poor state.

The number of canons never appears to have numbered more than eight, and sometimes this had fallen to just three. At the time the priory was dissolved in June 1536 there were five canons residing at Tortington. The valuable items held at the priory were all sold off and the site was later granted to Sir John Spencer shortly before his death in 1600. The buildings were left to decay and crumble, and the only surviving above ground remains are the ponds to the south, and some parts of the refectory are incorporated into a barn at Priory Farm, which now occupies the site. During dry weather a large square feature with buttresses and internal pillars can be seen from above as a crop mark.

Hospital of St James (*c.* 1182–*c.* 1301)

The Hospital for the Leprous Sisters of the Church of St James was founded in around 1182. Very little is known of this establishment, which was located in the area of Park Bottom on the west side of the A284. By the beginning years of the fourteenth century, the chapel passed to the College of the Holy Trinity and it had been taken over by a hermit by 1435. Remains of the hospital were still visible in the early part of the nineteenth century, but nothing remains to be seen today.

Poling Preceptory (bef. 1199–1445)

Of unknown origin, it is conjectured that the preceptory of the Knights Hospitaller at nearby Poling was founded around 1199 on permission of King John.

By 1338, the Poling estate was the centre of the Order in Sussex, with the other estates being under its control. At Poling at this time was the knight preceptor, Peter ate Nasshe, a knight (Clement de Donewico), a chaplain, a steward, a cook, two preceptor attendants and two clerks to collect alms from the local area. The Knights Templar estates in Sussex (Shipley, Sompting and Compton) had also been granted to Poling in 1324.

The last preceptor at Poling died in 1442 and the preceptory was dissolved in 1445. When the whole Order was dissolved in 1541, the Poling estate was handed to the College of the Holy Trinity in Arundel. Today, only the thirteenth-century chapel of the Priory of St John survives as the easternmost part of a private residence.

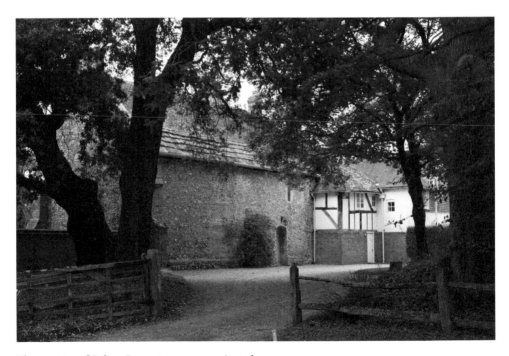

The remains of Poling Preceptory, now a private house.

Arundel Blackfriars (bef. 1253–1538)

As the third monastic Order in Arundel after the Benedictines at the priory and Augustinians at Calceto, the friary was the first establishment of the Dominicans in Sussex. Exactly when the Black Friars arrived in the town is not known, but it was at some point between May 1221 (when the Order first arrived in England) and 1253, the latter date being the first mention of the friary in the will of St Richard of Chichester. The founder of the Order at Arundel is also a mystery, but common speculation suggests that Lady Isabel, wife of Hugh d'Albini, may have been responsible, since Friar Ralph de Bocking, believed to have been at Arundel, dedicated his biography of St Richard to her in 1243.

Information on the friary is scarce and mention is not made again until 1290, when the friars received money in the will of Eleanor of Castile, and then again in 1291 when Edward I donated money to the twenty-two friars residing there in that year. There is another blank space in the historic record until May 1314, when the prior was stripped of his office; the reason for this course of action is unknown.

Another decade passes before documentary evidence is found, when, in 1324, the 2nd Earl of Arundel donated 2 acres of land to the friary for the keeping and grazing of cattle. Edward II also passed through the town in this same year, at which time the number of friars had fallen slightly to twenty. There is another massive gap until the will of William Laxman of Reigate Castle in 1374. This was followed by a large gift in the will of the canon of Chichester in 1381; the money was to pay for the friars to preach one mass for him at the high altar of the friary, and a second at the low altar, as well as to erect two glazed

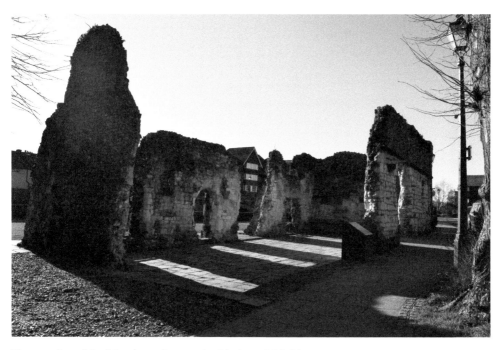

The remains of the friary's south range beside Arundel Bridge.

windows in the building. Around another decade passes before we find mention of the friary in the will of the 4th Earl of Arundel.

There is evidence of there being at least one anchorite at the friary, in the person of John Bourne. However, in 1402 he received a papal licence to relocate to another establishment owing to the extreme poverty suffered at Arundel making life unbearable for him. A few more brief mentions in church records make reference to the friary in 1410 and then not until 1527. In these latter years the friary appears to have been in severe decline, since there were just three friars in July 1538.

Henry VIII dissolved the monasteries in October of the same year, by which time numbers had slightly increased to five. It was this episode that allows us to know the names of the final inmates of Arundel Blackfriars: John Colwyll (prior), Wyllyam Cofy'ton, Wyllyam Welche, Rychard Damyk and Thomas Mattheu.

Due to its small size and even smaller value, the friary was left abandoned until 1540, when Edward Millet of Westminster purchased the two friaries at Arundel and Chichester. At this time, the one at Arundel consisted of the dormitories, chapel, burial ground, ponds, gardens, an orchard and 2 acres of meadow. Visible remains of the burial ground survived until the early nineteenth century.

The building itself was probably square in plan, but without an eastern side. The ruins seen today beside the river formed part of the south range. The north range is believed to have been the location of the friary chapel, with parts of the walls still surviving in a highly ruinous condition behind the post office; the west range ran adjacent to the post office.

Inside Arundel Blackfriars.

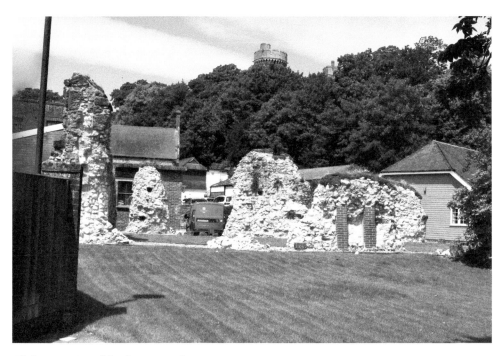

All that remains of the former north range.

College of the Holy Trinity (1380–1544)

On condition of annual payment to the king for the duration of war with France, the 4th Earl of Arundel established the College of the Holy Trinity on the site of the Priory of St Nicholas in 1380. The college absorbed all the estates owned by the former priory and a number of other lands throughout Sussex over the following decade. The 5th Earl of Arundel then left seven of his manors to the college upon his death in 1415.

The college was substantially larger than the priory that it succeeded, having almost four times as many inmates than the priory had at its peak. However, by 1442 the numbers had fallen dramatically from twenty-two to just eight, and a visitation in that year found a number of failings, including inmates not following rules, buildings in disrepair, lost jewellery and a substantial debt of £40 [£25,720.38] that had been incurred by the inmates. A visitation of 1478 reported little, if any, improvement.

The College of the Holy Trinity appears to have been looked upon favourably by Henry VIII, and not only did it survive the dissolution of 1538, but in 1541 the king personally granted to the college the Knights Hospitaller preceptories at Poling and Shipley. Its survival wasn't long-lived, however, because in 1542 the son of the 11th Earl of Arundel proposed its dissolution, subject to gaining permission of the king, the 11th Earl and the master of the college. He appears to have failed to gain all the necessary permissions and it wasn't until becoming the 12th Earl in 1544 that he managed to force the dissolution of the college by surrendering it to the king, who in turn sold it back to him.

The building was put to a number of uses in the ensuing decades, and like much of Arundel, it was damaged during the Civil War; by the end of the eighteenth century what

remained was little more than the outer walls and the south wing was rebuilt to include a Roman Catholic chapel in 1789. In the early nineteenth century, the 11th Duke of Norfolk began to repair the structures, and over the course of that century the east wing was rebuilt and used variously as a school, old peoples' home and then in *c.* 1870 St Wilfred Priory was established on the site, incorporating the surviving remnants of the college, and included the castle laundry which employed the so-called 'fallen women'.

The main entry to the college was via a still-extant gateway in the south-west corner. This gate originally had a Sanctuary Ring attached (a metal ring not dissimilar to a large knocker) that allowed someone upon touching it to claim immunity from arrest. Breaching sanctuary was a serious matter, as was discovered by those who seized John Mot at Arundel in March 1404. Acclaimed Victorian historian Mark Tierney related that Mot had been committed to the castle's prison for robbery, but managed to escape. The constable and a number of inhabitants gave chase and knowing he would be unable to outrun his would-be captors, Mot headed to the college and took hold of the ring and claimed rights of sanctuary. However, the constable proceeded to arrest Mot and led him back to the prison. Two of those involved in these events were summoned by the bishop and found guilty of violating the law of sanctuary, and were ordered to make a pilgrimage to Chichester, present an offering at the shrine of St Richard and then to be beaten with a cudgel five times through St Nicholas' Church and afterwards to kneel and recite the Pater Noster, Ave and the Creed five times each before the crucifix at the high altar. The cudgelling was soon commuted to an offering of a burning taper at the high mass at the college chapel on the following Sunday after the captors admitted their error and returned Mot to the church.

St Wilfred Priory.

Hospital of the Holy Trinity (1395–1546)

Located to the north-west of St Nicholas Church, the Hospital of the Holy Trinity was associated with the college of the same name and oversaw the care of the town's elderly and infirm. The north-western portions of the current churchyard wall are original to the hospital.

The hospital was first envisaged by the 3rd Earl of Arundel to coincide with the creation of a chantry within the castle. As with the college, it was the 4th Earl who succeeded in having the late earl's wishes fulfilled. The college came first, but in 1395 the 4th Earl removed a portion of land for the hospital. The original inmates were twenty poor, aged or infirm servants and tenants of the earl who were able to recite the Lord's Prayer, Salutation and Creed in Latin. They were to be overseen by a resident priest and a chaplain, and the inmates were able to elect a prior from among themselves.

The hospital was not a medical institution that we would think of today, but was perhaps more akin to a religious workhouse, where the inmates were put to work. Such work included weeding the churchyard, gardening and nursing other inmates. The inmates were to be dressed as monks in brown robes and were referred to as brethren; the robes were replaced every Christmas. The hospital and its chapel were suppressed in 1546. The building was demolished in the early eighteenth century, save for those small portions now forming part of the churchyard wall; a vicarage was sited there until that also collapsed at the end of the century.

Remnants of the hospital can be seen in the churchyard.

54

Quaker Meeting House (1674–1845)

The Quaker Meeting House, on the site of the much later Arun Street Baptist Chapel, was founded during a time of great persecution in the mid to late seventeenth century. The Quakers originally met in another private residence in Tarrant Street, but the owner (Nicholas Rickman) was imprisoned with his wife at Horsham Gaol in 1656, having been committed there by the mayor of Arundel for challenging the established church. Also in 1656, Thomas Lacock was sent by the mayor to Horsham for four months and to be whipped and chained in irons for preaching in public, while Joseph Fuce was transported to Jamaica. In 1658 Thomas Lacock was again imprisoned, this time for over a year, having been forcibly removed from a meeting at Rickman's house. The following year, Rickman was back in Horsham Gaol, along with Edward Hamper, for challenging Arundel's priest about the doctrine he was preaching. On 30 November 1662, Nicholas Rickman, Edward Hamper, William Turner, Tristram Martin, John Ludgater and John Beale were all arrested at one of their meetings in Tarrant Street and committed to Horsham Gaol once more. At the next Spring Assizes, the same group of men, along with Henry Woolyer, Richard Clarington, John King, Richard Lamboll, John Leonard and John Linfield, were all fined and sent to Horsham for two months, and then removed to the house of corrections for a further three months.

The meeting house was demolished for this former Baptist chapel.

On 7 February 1663, Rickman, Hamper, Turner, Martin, Woolyer, John Shashold, William Clayton, Richard Newman and John Baker were forcibly removed from one of their meetings at gunpoint by soldiers and were sent to Horsham Gaol again. Rickman, Turner and Martin were in front of the magistrates again at the next assizes, where they were each handed a hefty fine and sent back to prison for meeting in Arundel. Edward Hamper was in court again on 2 October 1665 for the 'crime' of failing to attend church.

Tristram Martin and his wife, along with John Cucknall and his wife (also from Arundel), were all excommunicated from the Church of England in 1673 for having lived together as though married couples, but having not abided by the ceremonies of that Church. Thomas Shepherd was excommunicated in 1677 for refusing to pay towards the repairs of Arundel church, the same happening to Nicholas Rickman and Edward Hamper in 1678.

On 14 January 1683, Edward Booker, William Garton, Henry Mills, Thomas Shashold, Jacob Knowles, William Longford and Thomas Parsons were sent to prison by the Arundel Quarter Sessions for not attending church and refusing to pay the resultant fines. At these sessions, Richard Green and Margery Wilkinson were sent to gaol for being present at an illegal meeting, and seven other Arundel men (including Rickman) who had already spent three months at Horsham had their sentences further increased.

It wasn't just the Quakers themselves who were persecuted. In 1686 the king had already outlawed the imprisonment of Quakers, but the Church of England cracked down even harder in other ways, ruling that no one was to have any dealings with them, nor to buy from or sell to them, nor gift to them any provisions. After Henry Elliott, a Quaker from Angmering, managed to get a miller in Arundel to grind his corn, the miller found herself brought up before the ecclesiastical court, given a fine, and threatened with excommunication if she milled his corn again.

In 1674, Edward Hamper leased his premises on the corner of Tarrant Street and Arun Street to Nicholas Rickman, which was converted into a Meeting House and burial ground. The number of Quakers in Arundel declined over the following 150 years and the Meeting House gradually fell out of use. By 1845 the building ceased to be used; it was demolished in 1867 and the Arun Street Baptist Chapel was erected on the site. The Quaker burial ground still exists under the garden of a nearby house.

Trinity Congregational Church (Original Site) (1784–1838)

Protestant nonconformity was quite popular in Arundel in the late eighteenth century, and the interest in the Independent Christian movement was such that a chapel was built in Tarrant Street in 1784. The congregation had aligned initially with the Countess of Huntingdon's Connexion, but later settled on the Congregational philosophy. The congregation continued to thrive and expand, so much so that despite an extension built in 1822, a new chapel was built nearby between 1836 and 1838. The old church (now No. 35 Tarrant Street) was eventually converted to commercial use and is presently a grocery shop. A blue plaque on the wall commemorates it origins.

The original Trinity Congregational Church.

Trinity Congregational Church (Nineveh House) (1838–1982)

Having been opened and consecrated in mid-1838, the congregation of the former chapel moved into their new, larger church just a few doors away. The new church had been designed and built by the highly respected architect Robert Abraham, who was also working on Arundel's town hall at the same time.

The second Trinity Congregational Church, now Nineveh House.

In 1966 there was another major change when the Baptist congregation from Arun Street merged with the Congregationalists, forming the renamed Arundel Union Church. A further merger in 1972 with the Presbyterian Church of England to form the United Reformed Church upset the Baptists, who split to join the Angmering Baptist Church the following year until they were able to build their own church in Torton Hill Road in 1980. The United Reformed Church survived at Tarrant Street until 1982 and the building was later sold. In 1990 it was taken over by the antiques market and was renamed as Nineveh House.

Providence Chapel (1845–68)
The Providence Chapel was built in Park Place in around 1845 to serve the town's Baptist congregation during a revival that was thriving at the time. Not much is known about the short-lived existence of this chapel: it closed in 1868 when the congregation moved to Arun Street and is now a private residence.

The former
Providence
Chapel.

St Barnabas' Church, Warningcamp (1863–1967)

St Barnabas' Church had its origin as a chapel of ease in the school at Warningcamp when religious services were held there in 1863. A separate chancel was added to the school in 1890, but it wasn't until 1923 that the building became a church in its own right. The church only survived for a little over forty years until it became too costly to run and it closed on 12 November 1967. The Chichester Diocese then sold the building the following year, when it was converted into a private residence.

Former St Barnabas' Church, Warningcamp.

Arun Street Baptist Chapel (1868–1967)

The first Baptist chapel was built in 1845 in Park Place, but owing to an increasing congregation, it moved to a new building in Arun Street on the site of the former Quaker Meeting House in 1868. The history of this chapel is quite uneventful, being served from the main Worthing Baptist Church for much of its existence, and in 1966 the congregation merged with the Congregationalist Church in Tarrant Street; the chapel closed the following year. It was converted to a shop and later became a private residence. It is now a bed and breakfast known as The Old Chapel.

6. Arundel on Film

With the fairytale castle, neo-Gothic cathedral and the historic town centre little touched by modern redevelopment, it is little surprise that Arundel has been a favourite setting for a number of films on the big and little screens.

One of the earliest films is the 1950 travelogue *Sussex Fortnight*, in which the eccentric Raymond Glendenning tours the South Downs around Arundel on a penny-farthing. We first see Raymond near Bury when he meets a large group of young women also out for a cycle. We follow them as they attempt to peddle up Bury Hill, but soon rather sensibly resort to reaching the summit on foot. The group stops momentarily at Whiteways (almost unrecognisable without the large roundabout) to debate where they should head next – Arundel or Littlehampton. They settle on Arundel by flip of a coin and continue their journey south on the A284. Passing the large beech trees lining the road, Raymond informs us that the trees here were planted by a local hermit and that no birds are ever heard, nor any nests seen in these trees. In town, the first stop is St Mary's Gate Inn, where Raymond pauses for a bite to eat while the women look around the cathedral. We are treated to several panoramas of the town before the group heads to the castle and Swanbourne Lake for a little natural history of the moorhens. Arundel is soon left behind as they next peddle on to Lyminster Church and thence onto Littlehampton. Although rather dated in more ways than one, this little film is still worth a watch as an interesting snapshot of 1950s Sussex.

Starring names such as Stanley Baker, Patrick Magee and Tom Bell, the 1962 crime drama *A Prize of Arms* follows the antics of a gang of criminals attempting to rob an army barracks. The gang manage to infiltrate the barracks and pose as soldiers to gain access to the pay office. As night falls, they cause a distraction by setting fires on the base and break into a safe to steal a small fortune. An officer on the base scuppers the gang's plans by alerting the police, but they manage to escape by following a convoy out of the barracks. In the final scenes, the gang is tracked down and cornered in an old barn, and in a desperate attempt to escape they accidentally set fire to it and their lorry, which soon explodes with the gang inside.

Arundel features very early in the film, when the gang's van drives along a very dark River Road and they haul up in an old warehouse on the corner of Tarrant Wharf. The next morning the van sets off along River Road again, and then along Ford Road. Through the magic of the movies they are then suddenly on Arundel Road at Hammerpot and can be seen passing Hammerpot Garage, crossing over what is now the A27 and continue in front of The Woodman Arms. In the film, the van slowly drives along a narrow dirt track leading up to an old barn where they change into their army uniform and transfer to a military lorry, before proceeding west along Crossbush Lane. The main part of the film takes place at the army barracks, which was actually RNAS Ford. The airfield had

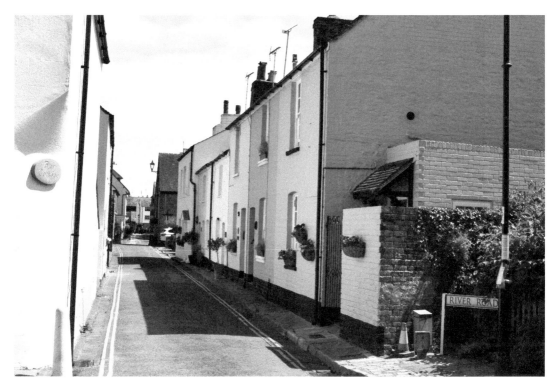

River Road features very early in the film.

The former Shaky Doo pub next to Ford level-crossing.

closed only a few years before filming took place and so it made an ideal setting for an army base. The buildings featured in the film now form part of Ford Prison and the Ford Lane industrial estate. When the convoy leaves the barracks after the robbery it can be seen travelling south down Arundel's High Street, past the Norfolk Arms Hotel, and a motorbike escort can be seen pulling in at the former Shaky Doo pub at Ford level crossing. The film ends back at the old barn, which was burnt down as seen in the film.

Arundel makes a brief appearance as a French countryside estate in the 1972 Ken Russell biopic *Savage Messiah*. The film portrays the life of the modernist French sculptor Henri Gaudier-Brzeska. In the film the first sighting of Arundel is a shot across the bridge in Mill Road, over which Henri and his lover, Sophie Brzeska, cross en route to his parent's countryside home on the estate of a French countess. The house in question is actually the old dairy at Home Farm, just beside the bridge. Arundel is left behind as the couple head off to London. Although a fairly obscure film, it is notable for being one of the first appearances for Helen Mirren, who features later in the movie. The late Peter Vaughan also appears in the film shortly before the Arundel scenes as a French museum attendant.

Thames Television produced a six-part adaptation of the John Wyndham novel *Chocky*, in 1984. The series followed Matthew Gore, a young boy, as he is contacted by an alien entity which, in turn, is using Gore as a source of information about life on Earth. No one else can see the alien, and Matthew's family initially think he has invented an imaginary friend, but it gradually becomes clear that an external entity is communicating with Matthew's mind. The alien grows attached to Matthew and when he and his sister are

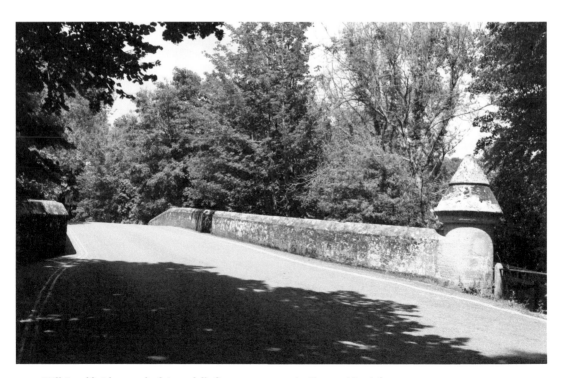

Mill Road bridge marked Arundel's first appearance in *Savage Messiah*.

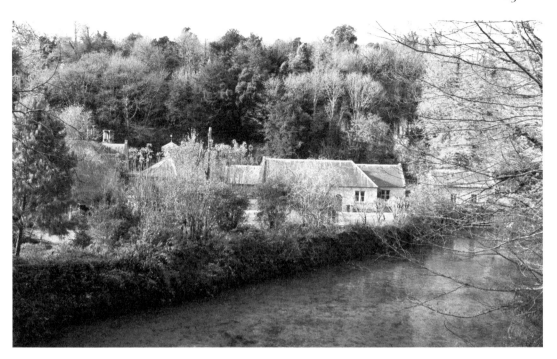

Home Farm posed as a French countess' estate.

involved in an accident, Chocky directly intervenes to save them, breaking its mission parameters. Chocky later breaks its connection with Matthew as the story concludes.

Set in Surrey, the fourth episode saw the Gores take a day trip to a riverside town, which turns out to be Arundel. Matthew's parents are seen exploring the castle while their two children stay with a family friend, Alan Froome, and his two children, playing and fishing along the banks of the Arun just south of the Fitzalan Pool car park. When Alan takes his son to get some refreshments, a small boat mysteriously breaks loose of its moorings upstream of a rickety jetty that Matthew and his younger sister are fishing from. Despite another girl shouting a warning, the boat smashes through the jetty, sending the two Gore children splashing into the muddy (and fast-flowing) waters of the Arun. In the next episode, Matthew reveals that it was Chocky who was guiding him to learn to swim and save his sister, but Arundel doesn't feature any further in the series, other than in brief flashbacks to the accident.

A year later *A View to a Kill* was partly shot at the nearby Amberley chalk pits (now Amberley Museum), which doubled as California's Silicon Valley. Christopher Walken's villainous Max Zorin plans to set off a large bomb in the mine in order to create a massive earthquake along the San Andreas Fault and flood Silicon Valley. He detonates a smaller bomb to flood the mine and kill his loyal henchmen and sidekick, May Day, before escaping in his airship hidden inside a cabin, rising above Amberley before suddenly appearing over San Francisco Bay. Meanwhile, May Day, who narrowly survives, is angered by Zorin's treachery and teams up with Bond (Roger Moore) to remove the bomb. They manage to retrieve it from a cavern and place it on a rail wagon with a

Boats still moor up where Chocky saved the Gore children.

faulty brake, causing May Day to sacrifice herself as Bond pushes the wagon out of the mine with seconds to go. Zorin's airship is once more over Amberley just in time to see May Day and the bomb leave the mine and explode in a cloud of smoke. California State Geologist Stacey Sutton appears over the hill and runs down to greet Bond (with whom she had previously managed to escape two of Zorin's assassination attempts), but she is kidnapped as Zorin swoops down in his airship. Bond manages to cling on to the mooring rope until the film's iconic finale at the Golden Gate Bridge. Moore was to soon star alongside Michael Caine in Michael Winner's 1990 comedy *Bullseye!* in which Arundel Castle makes a very brief background appearance as a train passes by in the foreground.

The castle makes another appearance as a substitute for Windsor Castle in the 1988 *Doctor Who* episode *Silver Nemesis*. The episode's plot involved a special statue that had the power to cause immense devastation in the wrong hands. As such, it had been launched into space in an asteroid centuries earlier. The asteroid crashes to Earth near Windsor (Arundel) Castle and three competing factions – the Cybermen, some neo-Nazis and an old sorceress named Lady Peinforte – vie to get hold of it before the others. The Nazis gain possession of the statue's bow, and Lady Peinforte finds the arrow, but the reasons why each faction want to assemble the statue is never explained. Nonetheless, as can be expected the Doctor, played by Sylvester McCoy, wins and manages to destroy the Cybermen in the process.

With the castle posing as Windsor, Arundel features heavily throughout the episode. Among the first locations is Arundel Park where the TARDIS appears and the Doctor and his companion, Ace, disembark, walking along the paths towards Hiorne Tower before stopping to sunbathe on the steep hillside (despite the fact that the episode is meant to be set in the middle of November). Hiorne Tower is the tomb of Lady Peinforte and stars

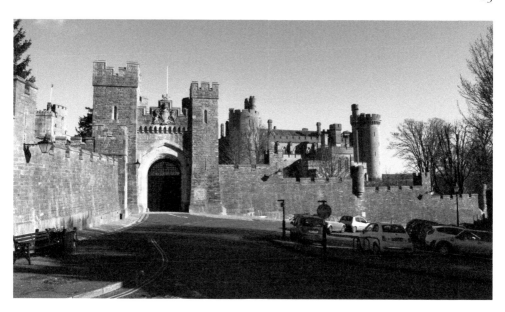

Above: Arundel Castle has been used several times to replace Windsor.

Right: Hiorne Tower in Arundel Park. (Kathryn S. Kraus/Shortcut Productions)

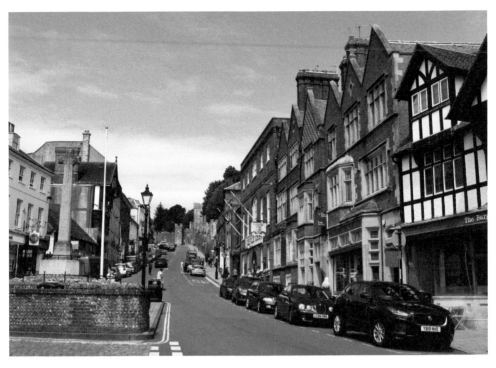

The High Street starred as Windsor town in *Silver Nemesis*.

La Campania had white windows when Lady Peinforte passed by.

prominently in a number of key scenes involving the Doctor, Lady Peinforte, the Nazis and, of course, the Cybermen. The town itself poses as the streets of Windsor when Lady Peinforte arrives on the scene, with the recognisable High Street frontages of the Norfolk Arms Hotel, La Campania and the militaria and antiques shop near the war memorial all appearing prominently. The junction of Tarrant Street and High Street is also a key recognisable local landmark little changed from when the episode was filmed. Lady Peinforte and her accomplice must have had a very long and tiring walk up and down the steep roads, since there are unmistakable shots along London Road too.

It was in 1994 that MacGyver made his appearance in Arundel in the movie adaptation *MacGyver: Trail to Doomsday*. In this film, the eponymous hero investigates the murder of a friend and discovers a secret nuclear weapons facility hidden inside Arundel Castle! Arundel actually poses as the fictional Carcroft Castle and we get our first glimpses of the town when MacGyver strolls along London Road – the unmistakable chimneys of Nos 9 and 11 London Road give away the location. In real life, he is actually walking away from the castle as his sidekick, Plato, arrives on his motorbike and picks up MacGyver. They head down onto the A284 where a police roadblock has been established (MacGyver being a wanted fugitive after being framed for another murder earlier in the film). MacGyver slips off the bike and heads into the woods. We follow him running among the trees as Plato clears the roadblock and then continues along the road where MacGyver is waiting for him. In the next scene, they have suddenly jumped to Mill Road, where MacGyver is once again dropped off, this time near to the Mill Road car park, where he crosses the ditch and climbs the bank into the castle grounds. Sneaking around the grounds, he passes by the Barbican as some cars enter through the gateway and then perches behind a tree to observe the armed guards at the gates and on the towers. In a typical MacGyver moment, he gains access to the castle by using his belt to climb up a rickety drainpipe on to the

London Road, where Plato helps MacGyver reach Carcroft Castle.

raised causeway leading up to the castle keep, narrowly avoiding a passing guard in the process. Inside the castle, he explores the seemingly abandoned halls and stairways until coming across the nuclear control room. The scenes from this point on were filmed in a studio, but when MacGyver finally finds the bomb, he is able to disarm it with the help of a conveniently stashed tennis racket with just two seconds left on the clock.

Arundel Castle once again acts in place of Windsor Castle in Nicholas Hytner's 1994 biopic *The Madness of King George*. The film starred Nigel Hawthorne (of *Yes Minister* fame) as the king and Helen Mirren has his queen. Jim Carter, perhaps best known for playing Carson in *Downton Abbey*, appears as the Leader of the Opposition. Much of the movie was filmed at various internal and external locations at the castle, as well as at Hiorne Tower. The castle next acts in place of Westminster Palace in Julian Fellowes' 1996 series *The Prince and the Pauper*, which stars James Purefoy. The castle then makes a number of appearances standing in for Windsor Castle over the next decade: firstly in the 2001 historical drama *Victoria & Albert*, in which Nigel Hawthorne stars in his second role in Arundel; secondly

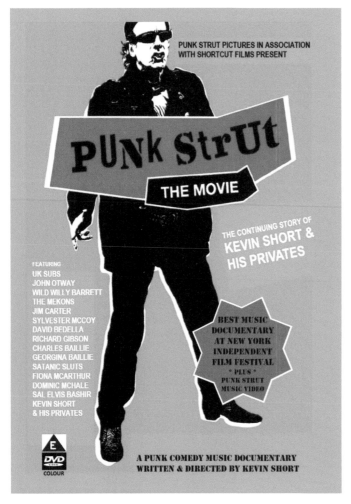

Punk Strut – Arundel's international award-winning film. (Shortcut Productions/Punk Strut Pictures)

in 2003 in the star-studded *Henry VIII*, with Ray Winstone in the title role; and finally in 2009 when Julian Fellowes returned to Arundel in *The Young Victoria*.

Punk Strut: The Movie, the winner of the Best International Music Documentary category at the 2010 New York Independent Film Festival, makes a dramatic break from the films that had so far been shot in and around the town. It would be quite fair to call the film a bit of an enigma – part documentary, part interview, part comedic fiction – but it is nonetheless entertaining and starred veterans of previous Arundel films, including Jim Carter (who now plays the leader of a motorcycle gang) and Sylvester McCoy as a DJ. It follows the adventures of Kevin Short and Richard Gibson (the latter in his alter ego of Rik Shaw) as they reunite with their former band mates. There is even a cameo appearance by Gibson's other alter ego, Herr Flick from TV's *'Allo 'Allo*, as a doorman at the Royal Hotel in Bognor Regis. The Arundel scenes include interviews and rehearsals in the old jailhouse, a gig inside No. 63 High Street (formerly a wine bar) and a semi-rowdy scene in the High Street outside the bar.

More recently, in 2017 the Barbican and Bevis's Tower at Arundel Castle stood in for Wingfield Castle in Suffolk and the Cathedral and Collector Earl's Garden as the medieval French town of Burgundy in the television serial *The White Princess*. In the same year, the castle starred in a very different role as a Belgian chateau occupied by the German High Command during the First World War in *Wonder Woman*. In the film, Wonder Woman and Steve Trevor both infiltrate the castle with intentions to stop the release of a new poison gas being developed by the Germans. For those familiar with Arundel, it can be quite shocking to see the Barbican draped with German banners and insignia.

The most recent appearance of Arundel on screen at the time of writing is Toby MacDonald's 2018 debut film *Old Boys*. Based in the 1980s and filmed mostly on location at Lancing College, some scenes were filmed at the Norfolk Arms Hotel and in the High Street.

A night-shoot in Arundel's High Street. (Shortcut Productions/Punk Strut Pictures)

7. Arundel's Titanic Tragedy

The blockbuster film *Titanic* brought the drama and emotion of the disaster vividly to life to a wide audience when it was released in 1997. The same sort of shock and sadness fell over Arundel for real on the morning of 15 April 1912 when the townspeople read the headlines reporting on the sinking. For one household in particular the news would have been especially distressing, since Henry and Mary Taylor's son, Bernard Cuthbert Taylor, was a steward aboard the ship.

Bernard had been born at No. 16 Bond Street, Arundel, on 31 December 1889 to Henry Walmsley Taylor and Mary Taylor (née Budd). The family was a large one and Bernard had ten other siblings, although two of them had already died by the time of the 1911 census; Bernard would sadly join them the following year.

His mother, Mary Budd, had been born at Adelaide Cottages in nearby Boxgrove in 1855, but Bernard's father, Henry, was not a local man originally. He had been born in Sedgely, Staffordshire, in around 1850 and had moved to Sussex to work as a gardener. They married at Boxgrove on 6 July 1874 before settling in Tortington by the time of the 1881 census, when they already had three children: Jane, Archibald and Elizabeth.

A decade later they appear in the census as living in Bond Street. Henry was still working as a gardener, with Archibald as an assistant. This is the first time that we find a mention of Bernard in the historical record, excepting of course his birth registration. He was just over a year old and was living with his brothers Archibald, Philip, Bruno and Henry. There were also two sisters then residing at the family home: Elizabeth and Marie.

Bernard was still at school at the time of the next census in 1901, when the Taylors were all still living at No. 16 Bond Street. The household had decreased in size by this point as some of the older children had left home. In addition to Bernard's parents there were Archibald (now working as a peg maker), Marie (a dressmaker), Bruno (a general labourer), Henry (a school monitor) and Bernard's two younger siblings, Josephine and Timothy.

All the children had vacated home by 1911, leaving just Henry and Mary looking after two of their grandchildren. At the age of sixty-one, Henry had unsurprisingly ceased his work as a gardener and instead was now the sacristan of the Roman Catholic Church of St Philip Neri – later to become the Cathedral of Our Lady and St Philip Howard.

No. 16 Bond Street, birthplace of Bernard Cuthbert Taylor.

Bernard had been working as a grocer's assistant in Arundel before he left home to join the Royal Navy, where he briefly served as a Boy First Class between 18 October and 9 November 1905 aboard HMS *St Vincent* – a sailing ship launched in 1815 which had been converted into a training ship at Portsmouth in 1862. He must have been among the last to have served aboard this ship, which was scrapped in 1906. His service record is a little hard to read, but he was discharged owing to a dental complaint in late 1905. Confusingly, the record states that he enlisted again on his eighteenth birthday in 1907 for a period of twelve years. This does not seem to have actually happened (unless he had another discharge soon after his second enlistment), because Bernard actually entered the merchant service as a steward. His first ship was the White Star Line steamship RMS *Teutonic*, before transferring to the brand-new liner RMS *Olympic* – the sister ship of *Titanic* – in 1911.

It was whilst aboard the *Olympic* that Bernard was involved in his first incident at sea, when the ship collided with HMS *Hawke* on 20 September 1911. Despite severe damage to both ships there were no serious casualties. In the first coincidental twist in the story of Arundel's connection to the *Titanic* disaster, the captain of the *Olympic* at the time of the accident was Captain Edward Smith, later to take charge of the ill-fated sister ship the following year.

Bernard transferred to the crew of the *Titanic* on 4 April 1912 as a third-class steward, just six days before the maiden voyage set off from Southampton. His position would have placed him on F and G Decks, the seventh and eighth decks down from the top respectively. Being this deep down in the vessel, he would have been among the first to know the seriousness of the situation when G Deck had flooded within just ten minutes of hitting the iceberg, and the water started to flow along the passages of F Deck just a

matter of minutes later. He died in the sinking and it is not known if his body was ever recovered. As such, he has no known grave and is commemorated with a brass plaque at his father's place of work, the now Arundel Cathedral.

The Taylors were to suffer a fourth tragic loss on 2 May 1918 when their son, Bruno Henry Edward Taylor, a signalman aboard HMS *Bombala*, was killed when the ship was torpedoed by *U-153* and *U-154* around 15 miles off the coast of Western Sahara. Henry Walmsley Taylor died in Arundel in 1929, and Mary died not long after in 1933.

In another interesting twist, the Russian steamer SS *Birma* had been one of the first ships contacted by *Titanic* at 23.42 on the night of 14 April 1912 – around the time the ship had collided with the iceberg. The steamer was only 100 miles away (and therefore was one of the closest ships) and although Captain Slopin changed course immediately upon receiving the distress signal, the ship's slow speed and masses of ice blocking the way meant he was unable to reach the scene until 08.00 the following morning, by which time the *Carpathia* was present and had already collected the survivors. The *Birma* had also received *Titanic's* final message at around 01.40 on 15 April before Jack Phillips' Marconi set went silent. The SS *Birma* had only been named so since 1905 and had originally been launched on 2 October 1894 as the SS *Arundel Castle*.

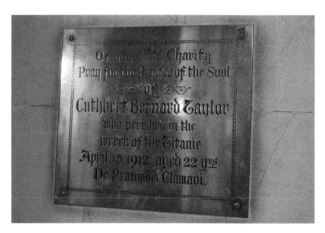

Bernard's plaque in the cathedral.

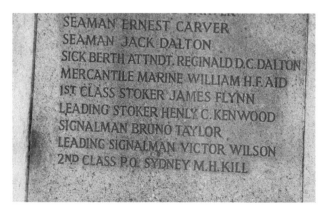

Bruno Taylor's name on the war memorial.

8. Weird Weather

Horsham, around 17 miles north-east of Arundel, holds the UK record for the largest hailstone, which fell on 5 September 1958 and weighed 140 g. Arundel cannot match this record, but can claim some unusual hail of its own. The first such report was on 7 July 1839 when what the *Brighton Gazette* described as large hailstones encapsulated by a thick layer of solid ice fell on the town. It began as a standard thunderstorm in the evening, but at 21.30 the ice fell. Over 5,000 panes of glass in the castle's conservatories were smashed and it was reported that every greenhouse and skylight in the rest of the town was similarly shattered. The report also stated that gardens and crops were ruined by the hail, and entire orchards stripped of their fruit. Another short, but intense, hailstorm befell Arundel on 6 August 1956 when the fifteen-minute downfall hit so hard and so suddenly that traffic on the A27 was forced to stop. In the town itself, it was reported that six buildings suffered roof damage from the sheer weight of ice that had built up.

Unusual or severe freezing weather wasn't just confined to hail. On 19 December 1859 an immense snow shower fell between Worthing and Chichester, with Ford being the worst hit as the snow piled up to over 4 feet deep. The railway at Arundel was completely cut off and it took a team of 100 workers almost the entire day to clear the lines of snow and allow the trains to continue rolling. A similar event occurred on 18 January 1881 when, owing to a continuous snowfall that began in the early morning and a strange coincidence that placed Arundel precisely at the crossing point of numerous arctic blasts, a large snowdrift built up in the town. Some roads became completely blocked and a number of shops and houses were snowed in, the inhabitants being unable to even open their doors. The nature of the winds meant that some roads and fields were left without a single snowflake, whilst others were entirely smothered. The Arundel omnibus was unfortunate to find itself caught on one of the affected roads and soon became stuck in a snowdrift; the passengers had to be dug out by a rescue party. Freezing temperatures remained throughout the month and a sad incident occurred to a groom stationed at Dale Park near Madehurst when he was journeying to the veterinary surgery in Arundel. His horse had a startle and threw the groom to the ground, where he lay unconscious in the snow, eventually freezing to death. No one knew what had happened to him until his horse returned alone the following morning.

Of course, the melting snow and ice can cause flooding, and in December of 1821 a record-breaking flood swamped Arundel, though the height of the water was unfortunately not recorded. Conversely, July 1945 was unusually dry for much of the country, except at Arundel where a weather station recorded total rainfall of 204 mm – the usual July average for Sussex being just 23 mm. Another severe flood affected large swathes of the UK on 17 September 1968 and in the local area an RAF helicopter had to be called out to assist police in the search for a man who had gone missing after his small boat capsized in the floods at Houghton Bridge.

Arundel's flood wall under repair, November 2019.

The River Arun at Houghton Bridge.

DID YOU KNOW?

In October 1927, Joseph Thorp reported seeing a strange blue flash in the sky just above the trees that lasted for thirty seconds as he reached Jack Upperton's Gibbet in Wepham Woods at Warningcamp. The blue flame travelled horizontally in complete silence before disappearing. The story was corroborated by two boys who had also witnessed the blue ball of fire. Was this a case of ball lightning, or something more mysterious at this notoriously paranormal hotspot?

Jack Upperton's Gibbet is still commemorated today by a marker post.

Aside from hail and snowstorms, Arundel has also been exposed to severe gales and hurricanes on more than one occasion. The earliest record that could be found was for 11 March 1818, when a hurricane hit most of the country and Arundel sustained extensive damage. Almost every house in town had either their roof blown off or chimneys blown down or otherwise experienced some other form of damage. Dozens of trees on the Duke of Norfolk's estate were uprooted and boats moored along the Arun were blown ashore. Another strong gale arrived on 29 November 1836 during which an eight-year-old boy narrowly avoided death. Captain H. Holmes and his son were walking in their garden when a gust of wind blew down a portion of wall they were alongside and buried the boy under a large pile of rubble. Captain Holmes hastily dug his son from the fallen masonry, finding him limp and apparently lifeless. After taking the boy inside he began to revive and eventually recovered, although he sustained extensive bruising and a broken leg. A boy at Angmering also suffered a broken leg in the storm when he was caught by a falling tree.

Arundel Castle was undergoing renovations in the spring of 1897 when, in early March, a gale tossed a steam crane perched 100 feet above the ground from one of the towers. At the same time a labourer working elsewhere on the estate was hit by a falling tree and sustained some serious injuries. Few of those living in the town in 1987 are likely to forget the hurricane that struck Sussex in October that year.

Storms such as those so far related in this chapter are usually accompanied by thunder and lightning. It is the latter one of these that has caused trouble for Arundel in years gone by. A colt, cow and calf were the unfortunate victims when lightning struck buildings at nearby Upper Barpham Farm on 6 June 1889. A labourer seeking shelter on the farm wasn't spared as the shed he was standing in was also hit, rendering him unconscious. Thankfully he appears to have recovered from the ordeal. A violent lightning storm was again witnessed on the night of 22 May 1914. The storm began with 'flashes of vivid lightning' before a massive rainfall that lasted for an hour and a half. However, as the rain died down, the lightning continued to get worse and it was reported that the Channel appeared as 'a vast expanse of violet' owing to the brightness and frequency of the lightning. The next victim of a lightning strike on 5 August 1931 wasn't as fortunate as the labourer at Upper Barpham Farm four decades earlier. This time the unfortunate man was fishing at Arundel when a bolt struck the end of his rod and killed him outright. The castle itself was hit by lightning the following year on 22 July. The 16th Duke of Norfolk (who was in residence at the time) had a wireless aerial installed between the east and south-east towers and it was this that attracted the lightning bolt during a sudden electrical discharge from the storm clouds above. Huge lumps of masonry up to 22.6 kg (50 lbs) were blasted to the ground below, but the south-east tower fared worse, with one dislodged piece weighing 1.5 tons.

The effects of lightning strikes are often compared to that of making the earth tremor, but Arundel has experienced a number of real earthquakes over the course of a century spanning from 1734 until 1834. The first one, on 25 October 1734, was felt as far east as Shoreham and as far west as Havant. The Duke of Richmond and Lennox at Goodwood House also reported being awoken by the shaking. On 1 November 1755

The tower on the right was damaged by lightning in 1932.

the shocks from the Great Lisbon Earthquake, which had almost completely destroyed that city, were felt in Arundel, and on 30 November 1811, the town's residents were again awoken in the early hours by a violent shaking. Furniture was observed to move and walls to wobble. A number of people were so aroused by the event that they ran into the streets to investigate the cause. The tremors were similarly felt as widely as Chichester, Midhurst, Petworth, Selsey and Bognor. A stronger earthquake hit the Portsmouth-Chichester area just before 2 a.m. on 6 December 1824. This one managed to set doorbells ringing and cause window blinds to unroll themselves. As in 1811, people left their homes in fear that they were about to collapse, though no reports were heard further away than Arundel. The final incident was another early morning one on 23 January 1834, being felt primarily at Arundel, Littlehampton and Chichester, and was described at the time as being 'a violent earthquake shock, with a loud rumbling noise'.

9. Arundel Anomalies

Often when researching for a book there are many, many interesting stories that are uncovered, but that do not fit into any chapter. Here, then, we take a walking tour of Arundel to uncover an eclectic medley of these fascinating titbits that were far too remarkable, strange, humorous or downright bizarre not to be featured in this book.

We start our journey at the magnificent Hiorne Tower in Arundel Park. Commonly listed among the numerous follies that can be found on the great estates across the county, unlike the follies at Slindon and Upperton (Petworth) which only found a functional use long after their construction, the Hiorne Tower was commissioned by the Duke of Norfolk in order to assess the work of the architect, Francis Hiorne, before allowing him to begin work at the castle. In front of the tower is a stone urn that was 'liberated' from Sevastopol Museum on 8 September 1855 after the infamous siege of the port city during the Crimean War. Continue on the footpaths back towards the town. As you near the junction with London Road you will pass Butlers Lodge. If you take a sneaky peak over the low stone wall you will see a row of white-painted buildings; this is the town's former drill hall. Continue along London Road to the cathedral.

Peer up at the large square tower that stands above the north-west porch and you may notice that it appears to stop rather abruptly, it's fairly plain appearance in stark contrast to the rich neo-Gothic decoration elsewhere. You may even notice that the cathedral seems to be missing a spire, and you'd be correct. It was originally planned by the cathedral's architect, Joseph Hansom, for a 280-foot-tall spire to sit atop the north-west porch, but this plan was deserted shortly after the square base (the tower seen today) had been partially built owing to the fact that the foundations underneath would not bear the immense weight. The cathedral instead has a more modest *fleche* at the east end. Hansom had previously used a near identical spire on his Catholic Church of St Walburge's in Preston, Lancashire, which still remains the tallest church spire in England.

Continue now along London Road and opposite Parson's Hill you will spot an ornate tower poking above the castle walls from the Collector Earl's Garden. As impressive as it is, on closer inspection you will see that it is actually built entirely of oak made to resemble stone! Head further along London Road until you reach St Nicholas' Church.

Enter through the ornamental gates and on your right you'll see the old priory/college wall dividing the churchyard from the grounds on the other side. Enter the church and behind the altar you'll notice that this divider continues right through the building, uniquely splitting the church building into the Anglican church and the Roman Catholic Fitzalan Chapel. This division resulted in a high-profile court case in May 1879 after the 15th Duke of Norfolk bricked up the chancel arch in 1873. This action was carried out after the arch had previously spent many years boarded up after the building had been left in a near-ruinous condition following the Civil War. When the churchwardens began to restore the church in 1872, they wrote to the duke to advise of their plans to remove

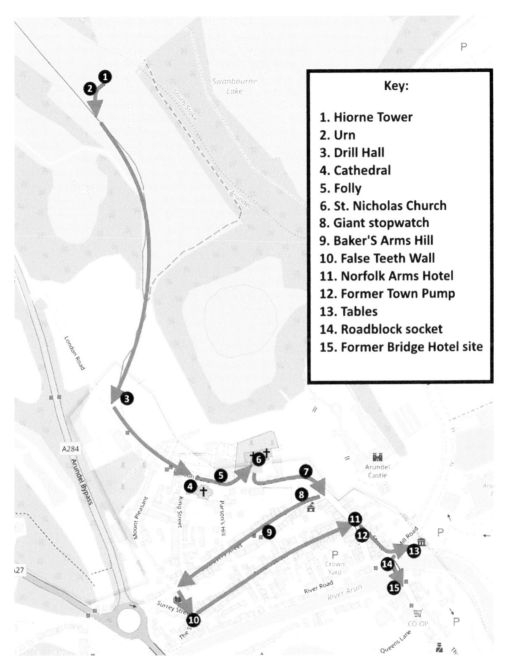

The Arundel Anomalies Tour. (Openstreetmap)

the boards that had covered the original iron grille between the two parts. The duke responded by having 'his' side of the old grille bricked up. In 1877 the vicar of St Nicholas removed a brick from the duke's wall and the duke subsequently took the vicar to the High Court for trespass in 1879. The vicar argued that the chapel belonged to the church and not the duke, who had neglected the chapel and allowed it to fall into ruin, and that

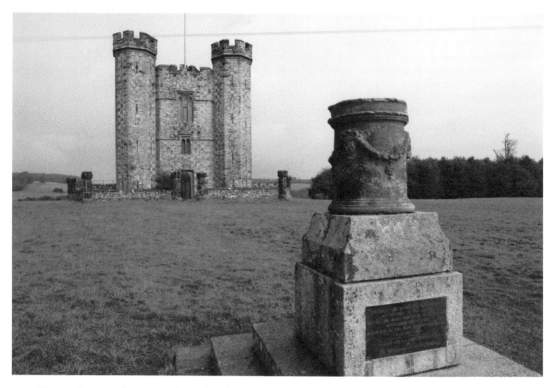

Hiorne Tower and Sevastopol urn. (Kathryn S. Kraus/Shortcut Productions)

The former drill hall peeking above the wall.

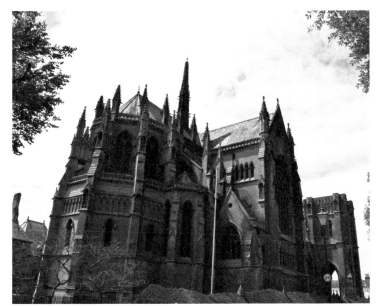

Above: The cathedral's 'missing' spire is on the right.

Right: St Walburge's Church, Lancashire. (Francis C. Franklin)

Below: Only up close is the folly revealed to be wooden.

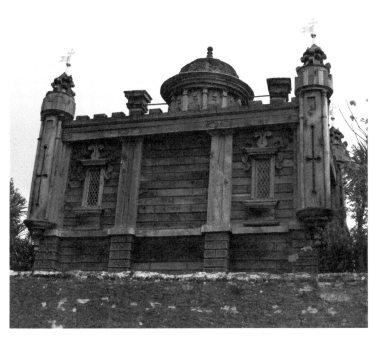

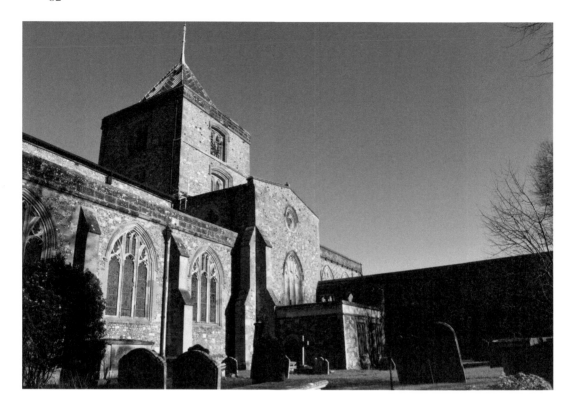

Above: The external divider between the Protestant and Catholic parts.

Left: The grille has only opened nine times since the 1640s.

The stone pulpit in St Nicholas' Church.

the church had a right to air and light to enter from the chapel. After a lengthy case, the judge ruled in favour of the duke on the first question (affirming that the chapel is in the sole ownership of the Dukes of Norfolk), but although not ruling in favour of the vicar (and actually awarded 40s [£132.37] against him for removing the brick) he urged both sides to come to a mutually acceptable arrangement to allow light and air to enter the church side. In the end, the duke removed the wall and the old iron grille that had been in place since c. 1380 was reinstated as the only physical barrier between the two parts. A locked gate exists in the grille and an information board in the church advises that it opened for the first time since at least the Civil War (if not centuries earlier) in 1977, and has only ever been opened eight times since, the two most recent being in 1995 and then at the First World War Centenary in November 2018. Other items of interest to look out for in the church are its several wall paintings and the magnificent carved stone pulpit that is of similar age to the building itself.

Because of the locked gate, the Fitzalan Chapel can only be accessed through the castle estate upon payment to enter the grounds. However, on 26 July 1901 the supposed relics of St Edmund were housed in the chapel under the guardianship of the 15th Duke en route from the Basilica of Saint-Sernin in Toulouse to their intended new place of internment at the high altar of the new Westminster Cathedral. The following day a procession carried the saint's remains from the chapel to another located within the castle itself, where they were originally meant to stay until the shrine in London had been completed. However, when Dr Charles Biggs, of Oxford University, and the famed ghost story writer and Cambridge scholar M. R. James cast doubt on the validity of the relics an inquiry was held by the Archbishop of Westminster who concurred with the scholars. The Archbishop of Saint-Sernin launched his own commission, which ruled in favour of the relics, but no claim for their return was made. Further disputes between various establishments in England over the fate of the relics ensued over the following decades and as a result, they still remain housed in the duke's private chapel in Arundel Castle today.

Leave the church and Fitzalan Chapel behind and continue your journey eastward along London Road to the castle entrance at the top of High Street. Here, in 1899, the 15th Duke of Norfolk considered closing off the grounds completely to the so-called 'scorchers' – cyclists who rode in a dangerous manner, often speeding along with disregard to pedestrians. Quite when a ban on bicycles was introduced is not known, but they are certainly banned from the grounds today. Now, head down High Street until you reach the junction with Maltravers Street. Head down Maltravers Street a short distance; on the building directly opposite the entrance to the town hall (No. 6) you can see a giant pocket watch hanging in a bricked-up window above the front door. Continue westwards along the road. Somewhere in the vicinity of Baker's Arms Hill was the residence of J. Parry Cole, a once renowned music professor and composer. On 3 January 1859 Mr Cole accidentally caused a fourpenny-bit (slightly smaller than a modern five pence coin) to become lodged in his throat. Seeking urgent medical assistance, he was advised that surgery was required to remove it, probably ruining his career in the process. At this point a lady suggested that he stand on his head and a sharp blow be given to his back. Mr Cole assented to give it a try and, upon the doctor giving a hard whack, the coin fell out onto the floor. The Heimlich manoeuvre was not invented for almost another 120 years.

A giant pocket watch opposite the town hall.

Further down Maltravers Street is No. 44, on the corner with Parson's Hill. On the corner of the first floor you will see a small shrine featuring a medieval crowned figure with a sword in his right hand and a very weathered model of a church cradled in his left. It is believed to be Emperor Henry II, a favoured saint of the then duke. Continue along Maltravers Street almost to the end and turn left down School Lane; cross over to The Slipe. Here is a wall made of all sorts of strange and unusual items. It was created by local eccentric Geoff Bridges, the former town crier who sadly died in 1999 and was interred in a mausoleum he had built in his own garden, surrounded by dozens of Romanesque statues and 'hanged' effigies of local planning officials who had so sought to restrict his eccentricities over the years. In the wall you will find an old sundial, a clam-shaped fountain, stone animals, an old iron, a cannonball and even a couple of pairs of false teeth!

About-turn and walk east along Tarrant Street until the very end, to the junction once again with High Street. On 13 February 1845 you'd have been in great danger standing here, because a runaway horse and carriage came hurtling along Tarrant Street, across High Street, jumped and cleared the stable gates of the Norfolk Arms Hotel and, unable to stop, crashed violently into a shed at the other end of the hotel's yard. The driver ended up thrown against the shed and knocked unconscious. A passenger sitting alongside

Left: The Maltravers Street carving.

Below: How many strange items can you spot in the wall?

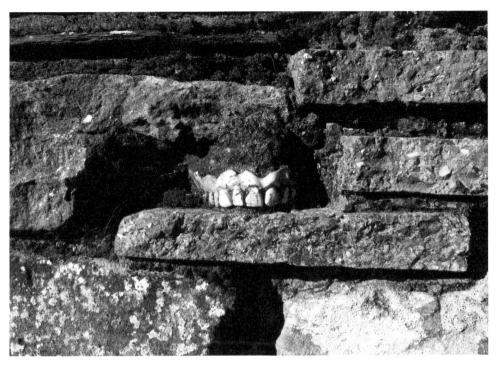

Probably the most surprising 'component' of Mr Bridges' wall.

Can you spot the cannonball, iron and more false teeth?

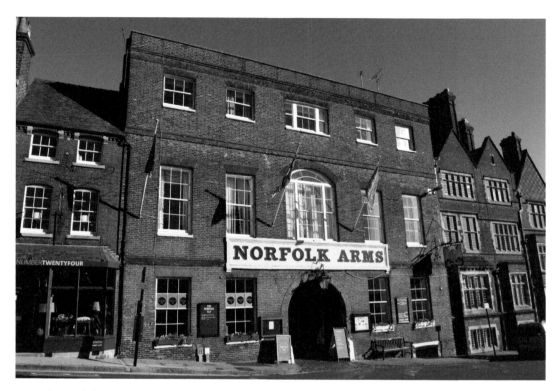

The Norfolk Arms Hotel.

The mystery anvil in the High Street.

managed to escape with just a minor bump to the head, but a second passenger behind him sustained concussion and serious injuries.

Cross over the road to the Norfolk Arms Hotel. Here, in the early 1920s was a Grey Parrot called Joey who came to some slight fame with his ability to imitate the hotel keeper. He could summon the hotel's dog, Simon, into the room by calling his name and would also make a sound like the telephone before saying 'Hello, hello. This is Arundel 45 speaking'. His biggest claim to fame was the unusual (but highly amusing) affirmation he'd make to guests: 'Yes, we have no bananas'!

Keeping to the same side of the road, walk a few steps down High Street to the militaria and antiques shop. Look high at the roof of the building and you will notice something sits atop it. It is quite common for buildings to be topped with a carved ball, eagle or perhaps some other animal, but Arundel instead has a stone anvil. It is thought that the building was once a blacksmith's and perhaps this ornamentation advertised that fact, but its lofty position is not particularly easy – nor convenient – to be seen by passers-by. On the front wall above the entrance to the adjacent building you can see an old stone clock.

A few steps away is the town's war memorial on the former market square. On the memorial's south side is where Arundel's old public water pump used to be located.

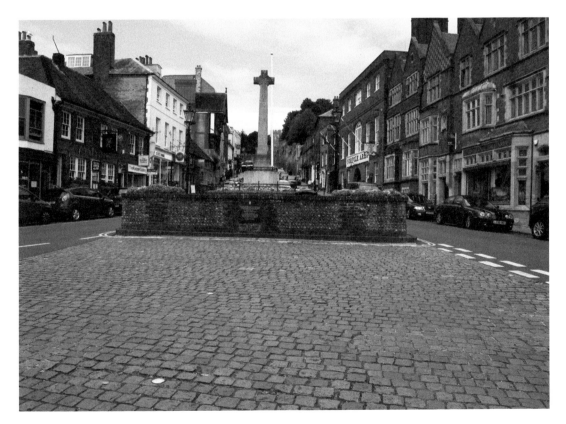

Market Square, site of the former town pump.

In November and December 1890 there was an outbreak of typhoid in the town. Within the first three weeks four people had died of the illness and by late December there were forty-three cases of this deadly disease. The origin traced back to the town's pump, which people were forced to use after the main waterworks malfunctioned. A second typhoid epidemic occurred in September 1893 when thirteen cases were recorded, of which two were fatal. Another outbreak, this time of diphtheria, spread through the town in March 1911. The cause this time was found to be infected French pigeons that hand landed in Arundel and were hunted and consumed by cats that then brought the disease into people's homes.

Heading south down High Street, turn left onto Mill Road and cross over to the gardens behind the friary ruins. Here, next to the museum, is a pair of stone tables. Amazingly, they are Grade II listed structures! Other unusual listed structures you will have passed on your journey so far are a series of cast-iron posts dating to 1819 at the top ends of Baker's Arms Hill and King's Arms Hill and a 1935 telephone box to the east of the post office opposite the friary ruins – all Grade II listed.

From the tables, turn around and walk west along Mill Road to reach the bridge. On the north-west side of the bridge, somewhat hard to spot, is a different coloured square slab half-jutting into the kerb stone This is all that remains of a Second World War roadblock that was built here to resist German tanks from entering the town. It would have consisted of iron 'hairpins' rising out of the ground on the pavements either side, and across the

The stone tables are an unusual Grade II listed structure.

The Mill Road telephone box, Grade II listed.

Left: Posts at Baker's Arms Hill, another Grade II listed structure.

Below: The roadblock socket is easy to miss.

Surviving hairpin at Shoreham, identical to that used at Arundel.

Martlets Court, better protected than the Bridge Hotel it replaced.

road would have been other such sockets that girders could quickly be placed in and solid concrete cylinders rolled out in front when the invasion alarm sounded. Continue to cross over the bridge. Looking south, on your right-hand side is Martlets Court, which is on the site of the former Bridge Hotel built in the late 1930s. The original Bridge Hotel suddenly collapsed into the River Arun a few years earlier when the foundations became undercut by the river.

This concludes the walking tour, but other fascinating anomalies exist outside the town too, such as the A27 road to nowhere, ending abruptly as it does at Crossbush, and the Knucker Hole at nearby Lyminster. But, the greatest anomaly of all must be the proposal by the Hon. Francis Albert Rollo Russell, son of former prime minister John Russell (who we first briefly met in Chapter 3), that would be the envy of anything that Donald Trump could concoct: a 300-foot-high, 30-foot-thick wall along the South Downs between Chichester and Arundel! Making the suggestion in 1902, he believed that his 'rainwall' would transform the climate, increasing rainfall a few miles north of the wall, but almost eliminating fog and other precipitation further inland, transforming Surrey and London into a sunny, dry haven away from any bad weather that may otherwise have plagued the summer months.

The A27 Road to Nowhere. But for how much longer?